S
I
T

matt karwen

Einleitung

Zu kaum einem anderen Tier verspüren wir Menschen eine emotionalere Bindung als zum Hund. Seit jeher sind sie unsere besten Freunde, verlässlichsten Partner und treuesten Begleiter – nicht zuletzt, weil Hunde uns auf subtile Weise das Gefühl einer besonderen, tiefen Verbundenheit vermitteln. Das breite Spektrum ihrer sozial-kognitiven Fähigkeiten ist in der Tierwelt einzigartig und beeindruckend zugleich, denn kein anderes Tier ist in der Lage unsere Blicke und Gesten so präzise zu deuten. In ihrer bunten Palette von Charakterzügen scheinen sie uns zu ähneln und wir Menschen neigen nur allzu gerne dazu, uns selbst in ihnen zu erkennen. Doch das innige Verhältnis zu unseren Weggefährten ist viel mehr als das bloße Ergebnis menschlicher Erziehung und Zuneigung: Hunde sind Charaktertiere, die vor allem dann eine verblüffende Vielfalt von Gefühlen zeigen, wenn wir es am wenigsten von ihnen erwarten.

Die Fotoreihe SIT zeigt die tierischen Hauptdarsteller auf eine Art und Weise, wie sie noch nie porträtiert wurden. Die frontalen Fotografien stellen die Individualität und den ungetrübten Blick auf die Persönlichkeit jedes einzelnen Protagonisten in den Fokus. In der neutralen Studioatmosphäre zeigen sich die Hunde entspannt und entsprechend ihrer natürlichen Persönlichkeitsmerkmale absolut authentisch. Losgelöst von äußeren Einflüssen offenbaren ihre Gesichter Stimmungen und Emotionen in allen Facetten, die von unbändiger Lebensfreude über zügellose Neugier bis hin zu ungenierter Gelassenheit reichen. Die Bilder fangen genau diese eindrucksvollen Augenblicke ein: sie sind direkt, unverfälscht, unaufgeregt. Die Hunde werden weder vermenschlicht noch überstilisiert oder karikiert.

Als Hundebesitzer hat Fotograf Matt Karwen ein außergewöhnliches Gespür für das Wesen der cleveren Vierbeiner. Er schafft eine intime Nähe zu den Tieren und hält die geheimnisvolle Magie dieser Momente in seinen Aufnahmen bildlich fest. Mit viel Geduld und Einfühlungsvermögen sind über einen Zeitraum von vier Jahren ausdrucksstarke, ästhetische Hundeporträts entstanden, die uns einen bisher nicht dagewesenen Einblick in die Persönlichkeit unserer treuen Gefährten gewähren. In ihrer minimalistisch-puristischen Ausarbeitung überzeugen die Fotografien nicht nur durch ihren hohen künstlerischen Anspruch – sie sind zugleich eine Hommage an den besten Freund des Menschen: den Hund.

Introduction

Undoubtedly, the emotional bond between humans and their dogs is a very special one. In a subtle way, they evoke a sense of intimate closeness in us – they have always been loyal friends, reliable partners and sociable companions. The remarkable variety of their socio-cognitive capabilities is unique in animal life. Hardly any other animal reads human gestures and facial expressions as precisely as dogs do. Their colorful bouquet of character traits is the reason why we often tend to compare ourselves to them. However, the close relationship to our buddies is much more than just the result of affection and training: dogs possess distinctive attitudes and a stunning variety of emotions they surprise us with when we expect it the least.

The photo series SIT shows its doggy actors in a way they have never been portrayed before. The frontal photographs focus on the individuality and the unclouded view on the personality of each protagonist. In the plain studio atmosphere the dogs are relaxed and, with regard to their natural personality traits, behave absolutely authentically. In the absence of outside influences, their faces reveal moods and emotions that range from joy over curiosity to serenity. The pictures capture these extraordinary instants: they are straight, real, unexcited, while the dogs are neither humanized nor stereotyped or caricatured.

As a dog owner, Matt Karwen has an exceptional sense for the nature of these smart animals. He creates a close intimacy and captures the enchanting moments in his photographs. In four years of patience and compassion, he has accomplished expressive, aesthetic dog portraits which give us an unprecedented insight into the personalities of our loyal companions. The minimalist, puristic images do not only convince the viewer through their artistic claim – they are also an homage to man's best friend: the dog.

OSKAR
Mix

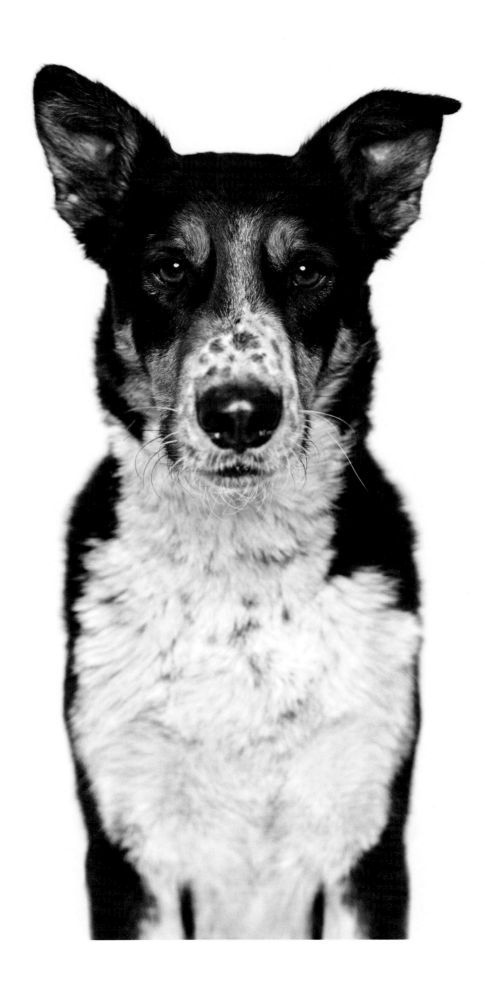

SMOKE
Rhodesian Ridgeback

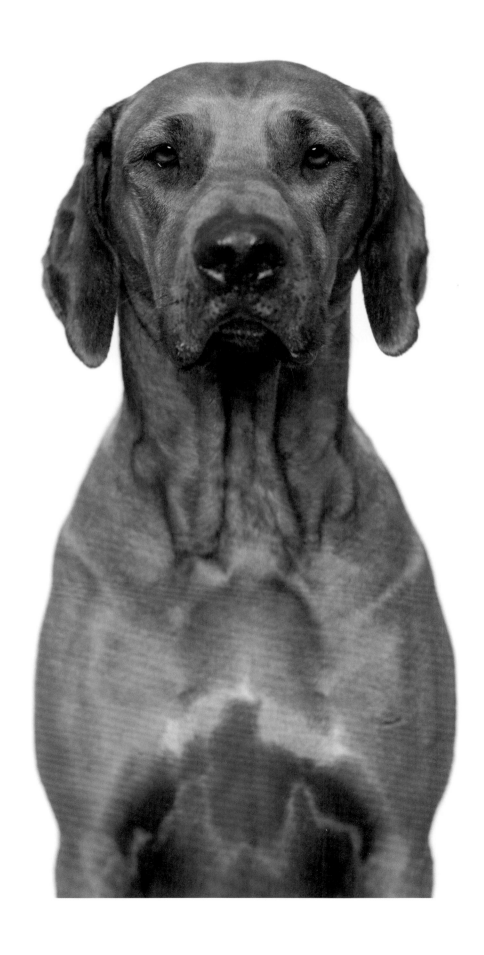

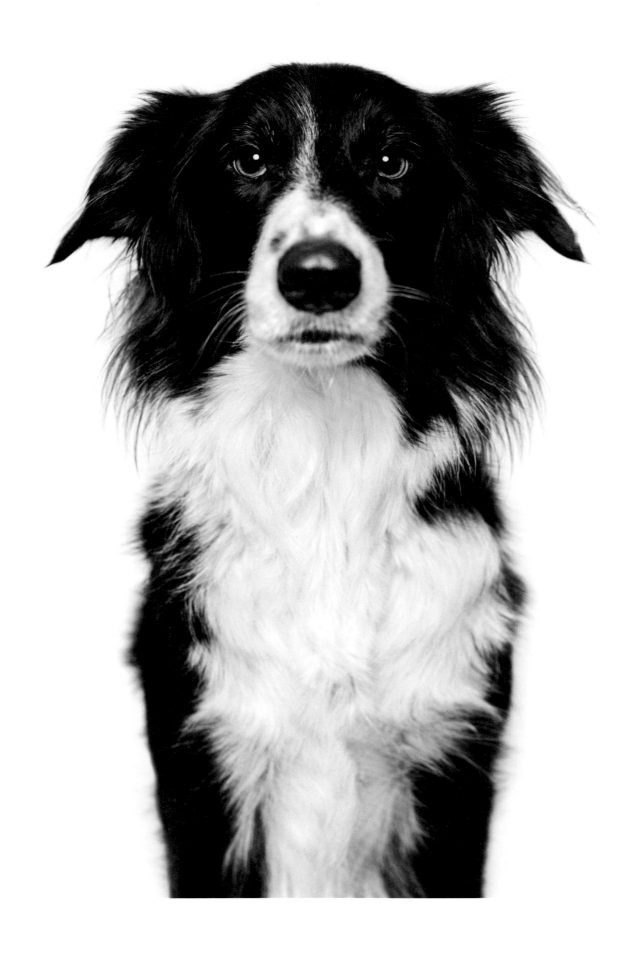

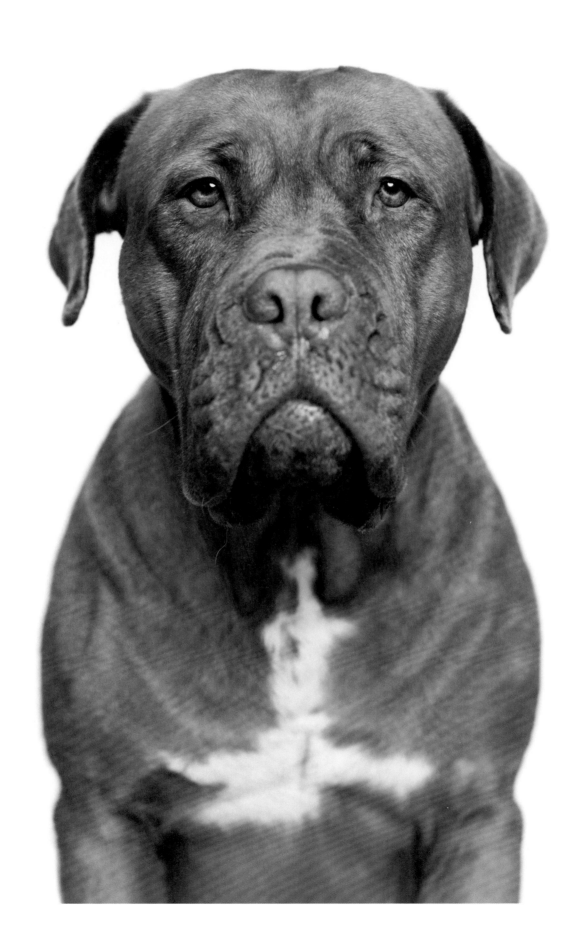

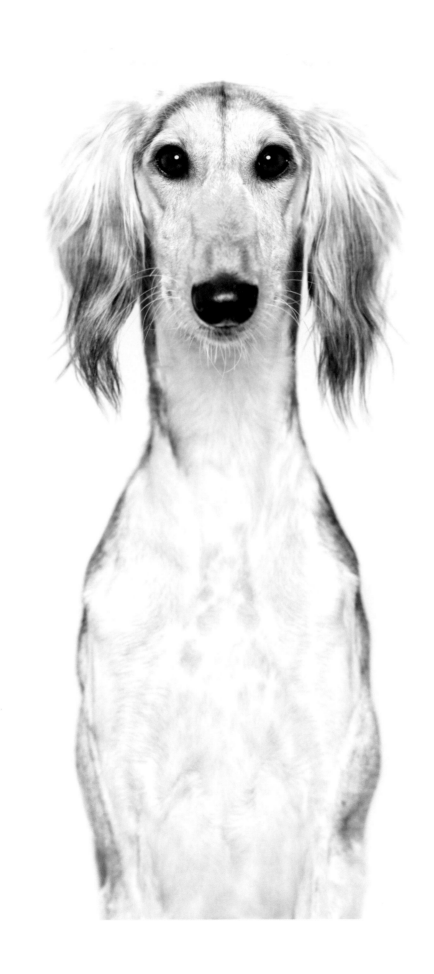

AFFINIT*
Dogue de Bordeaux

FARHAN
Saluki

RUSTY
Rough Collie

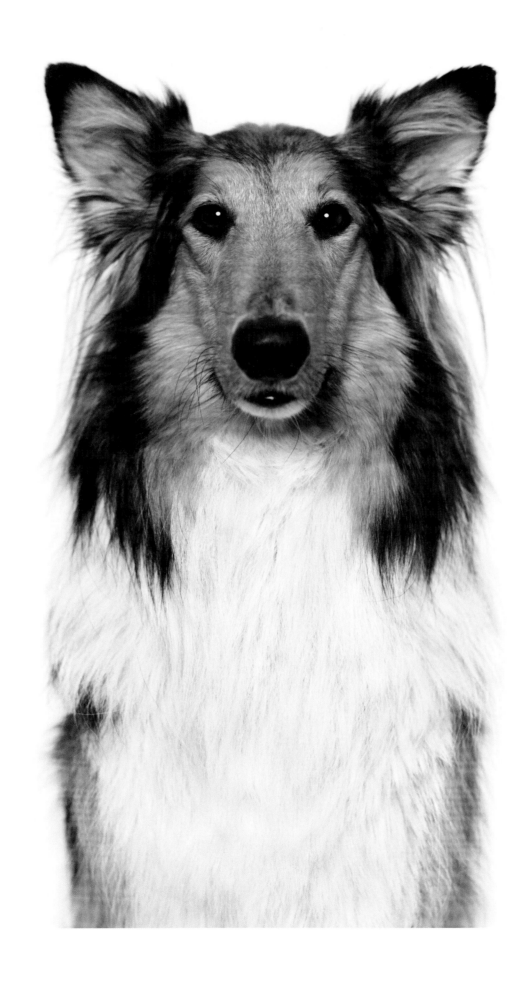

ACHILLE
Staffordshire Bull Terrier

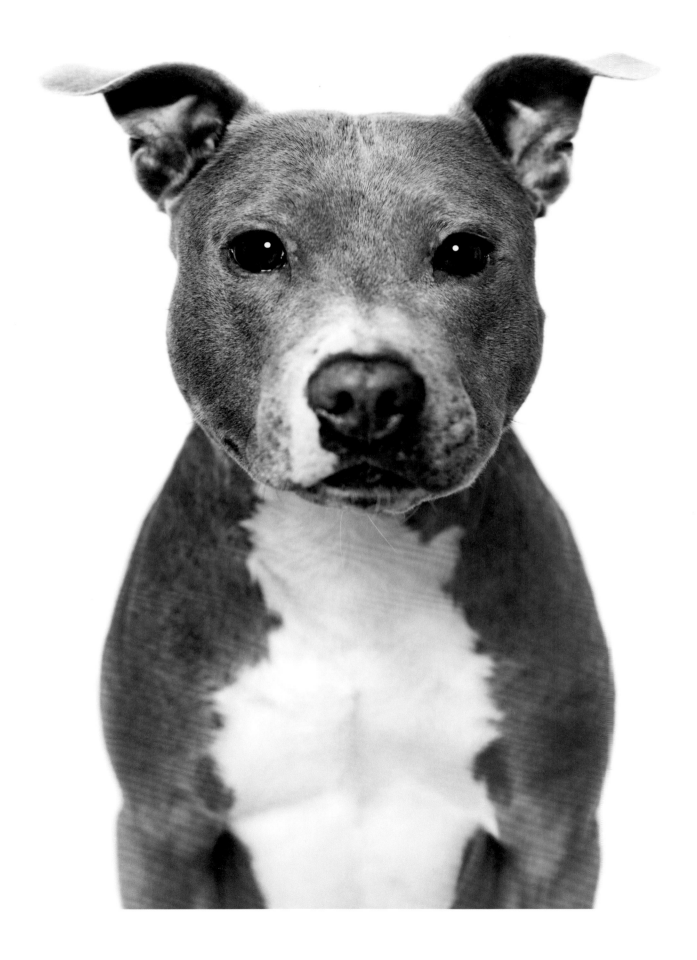

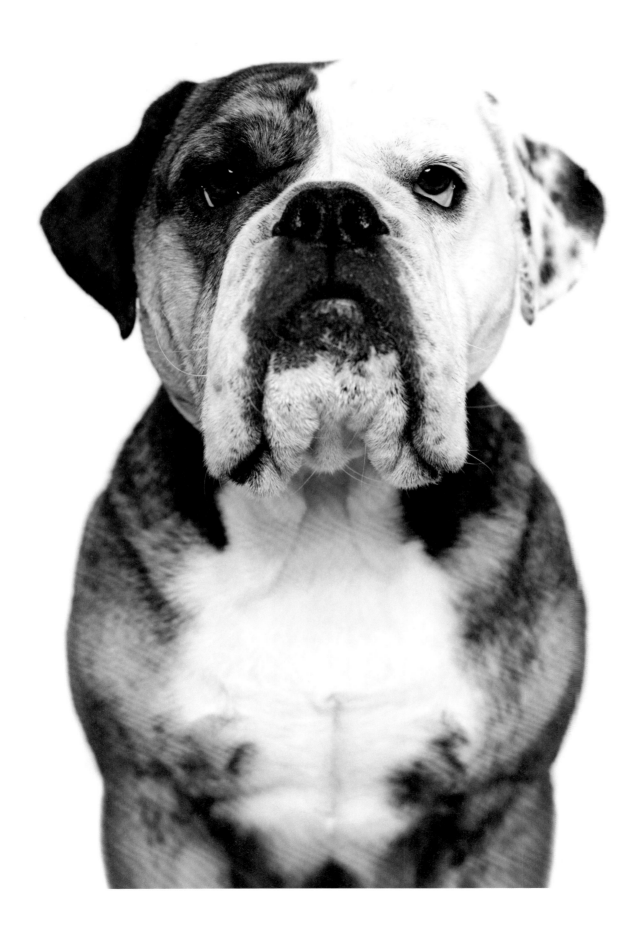

MICHL
Beagle

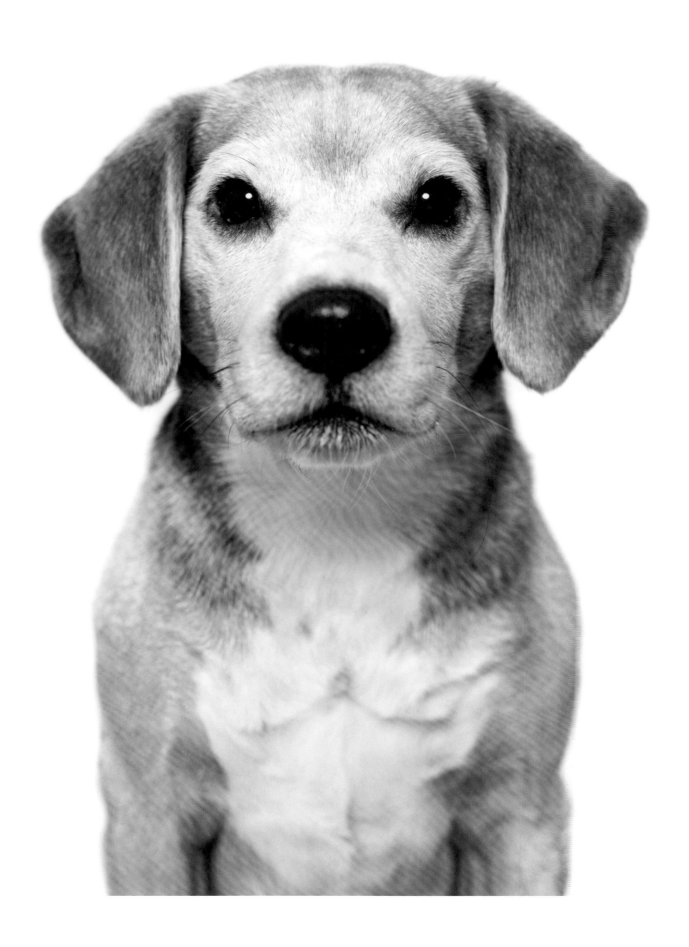

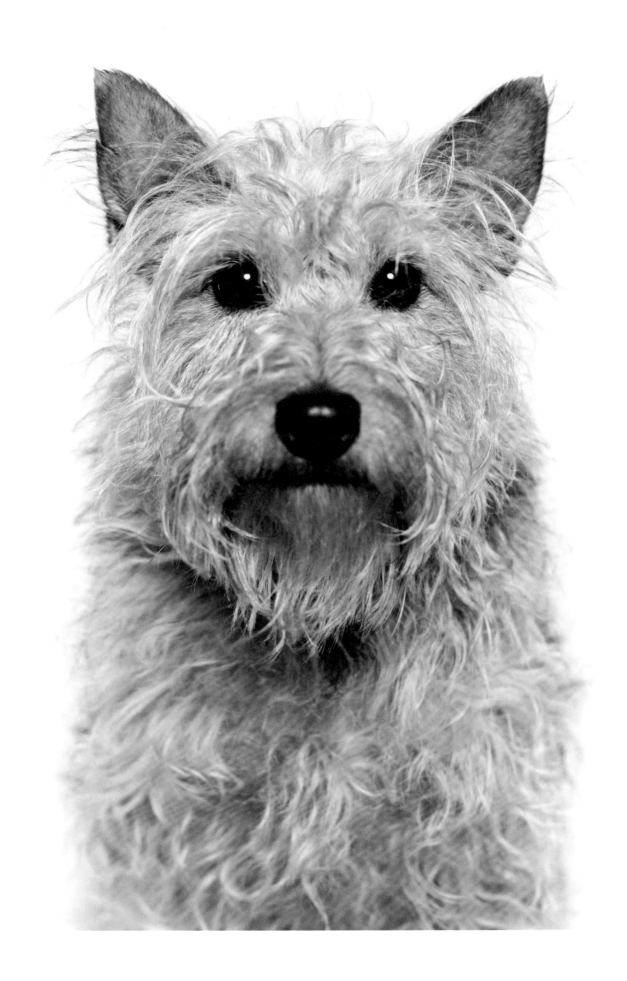

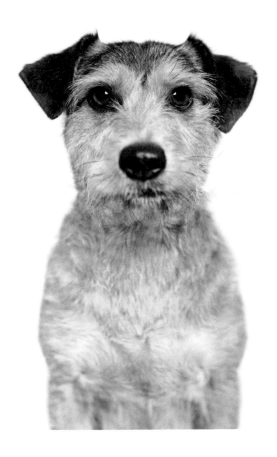

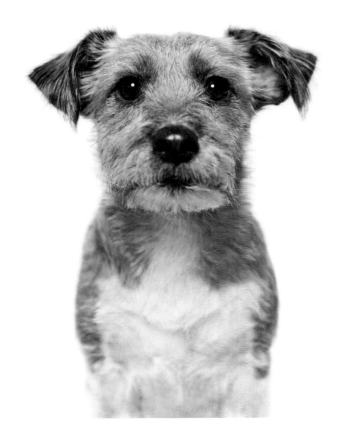

PEPPI
Terrier Mix

SUMMER
Parson Russell Terrier

LILLY
Welsh Terrier Mix

ERWIN
Perro sin Pelo del Perú

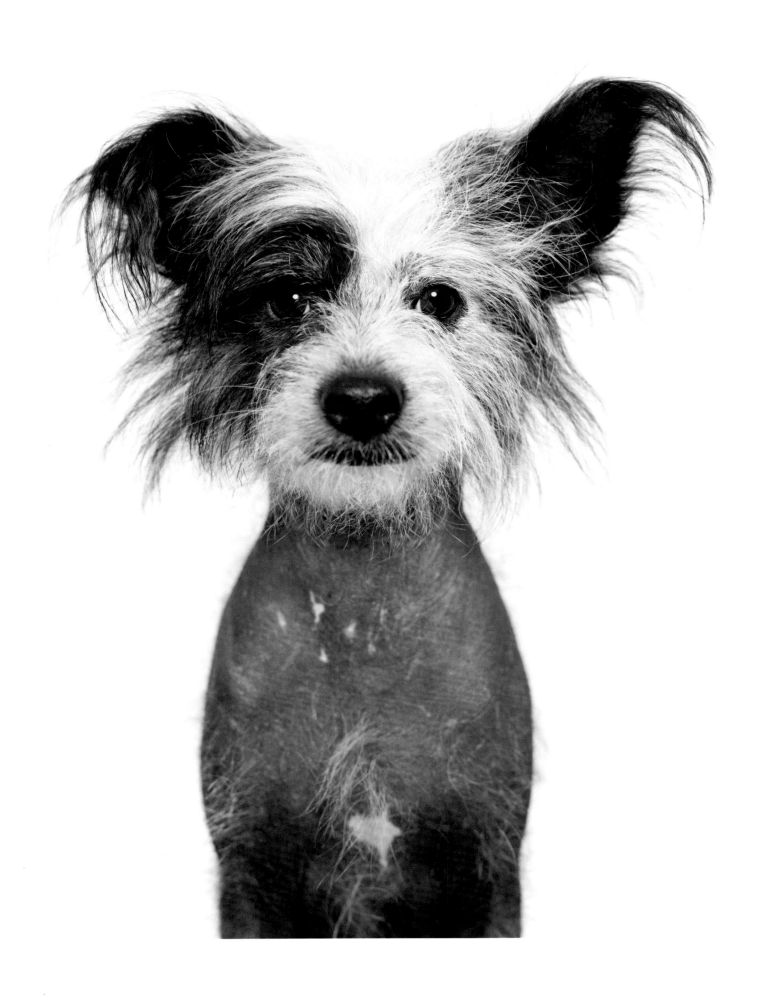

PERCY
Pug

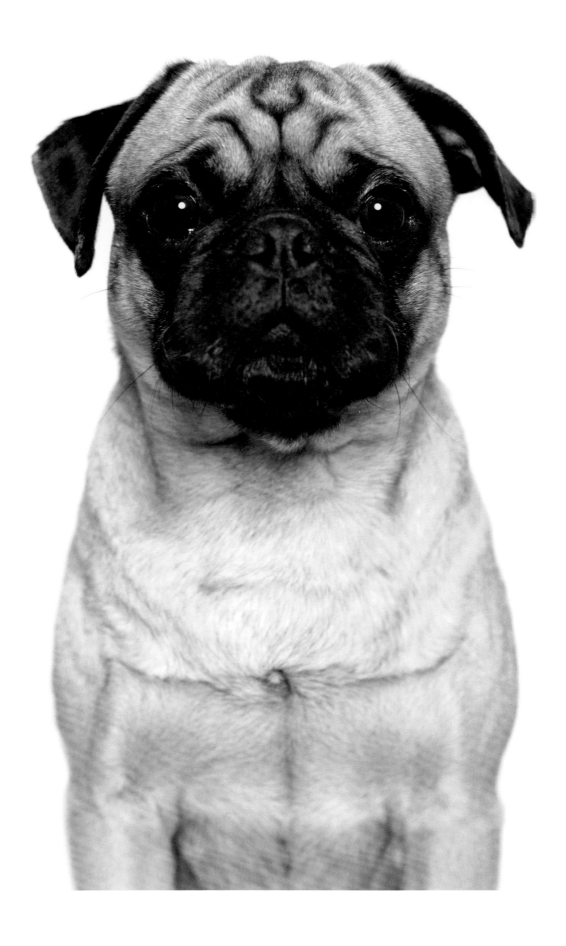

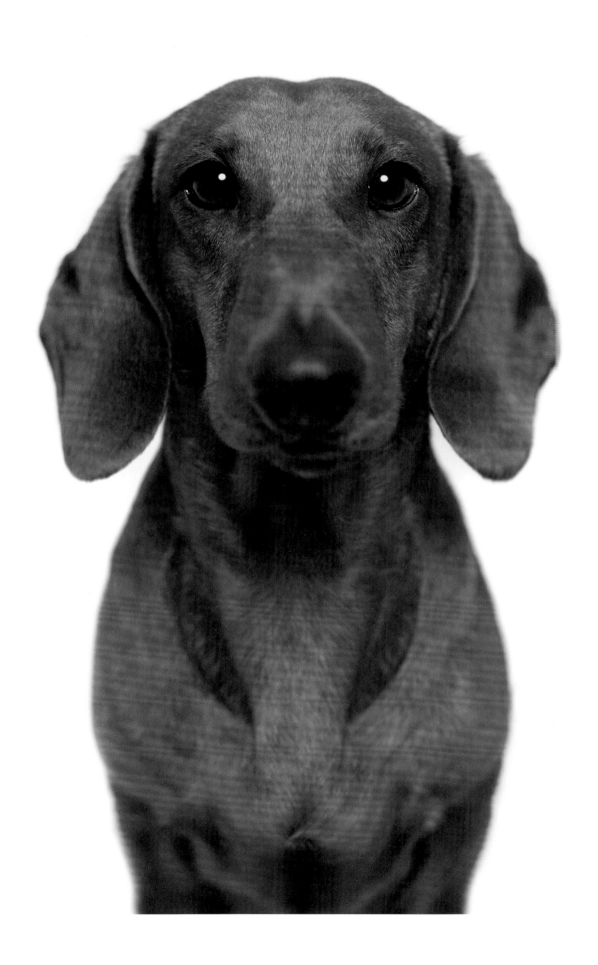

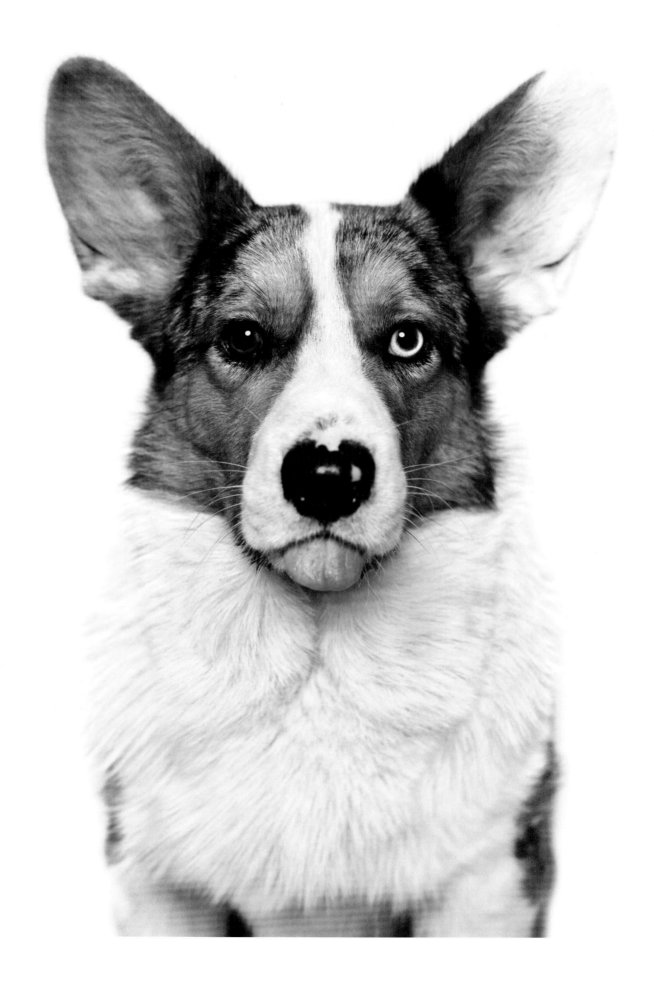

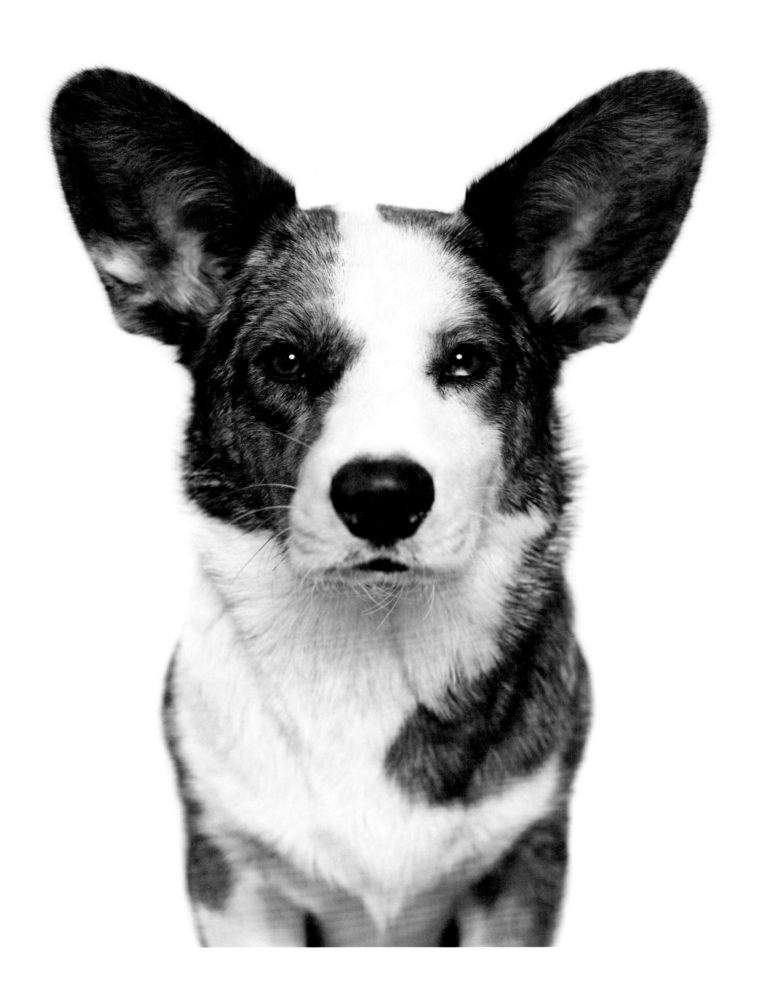

JACK
Welsh Corgi Cardigan

POLLY
Welsh Corgi Cardigan

TARKA
Eurasier

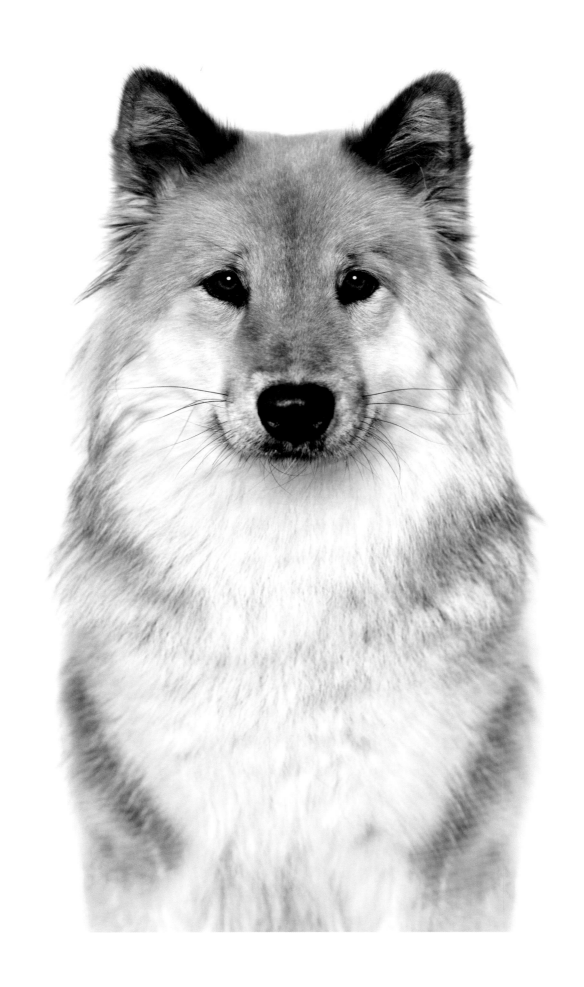

GIANNO
English Setter

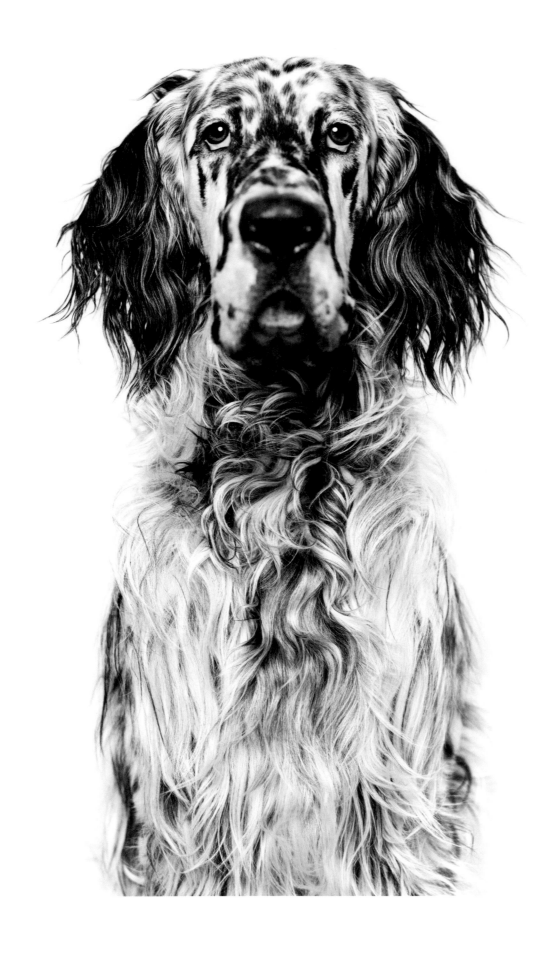

ARMANI
Shar Pei

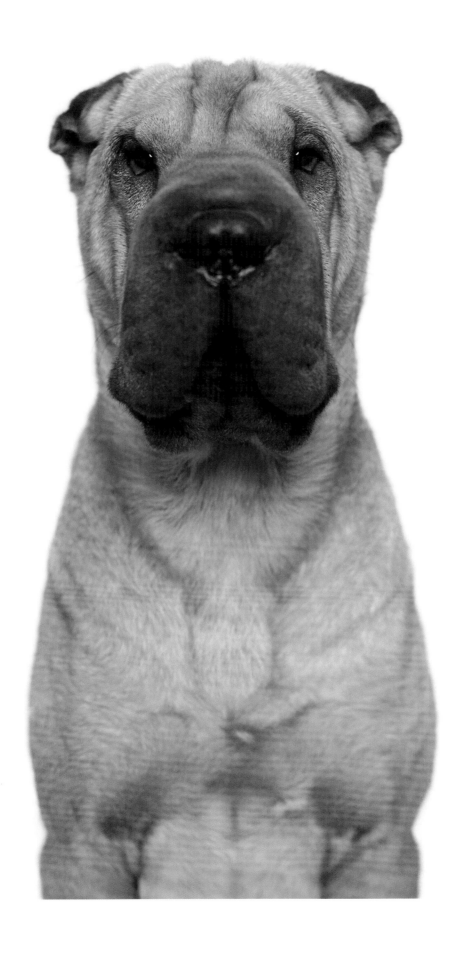

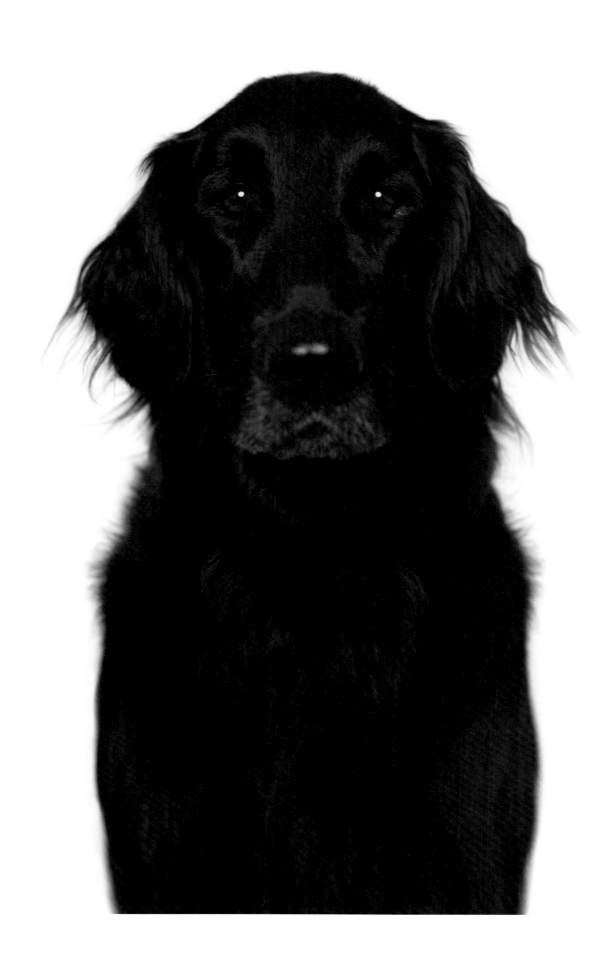

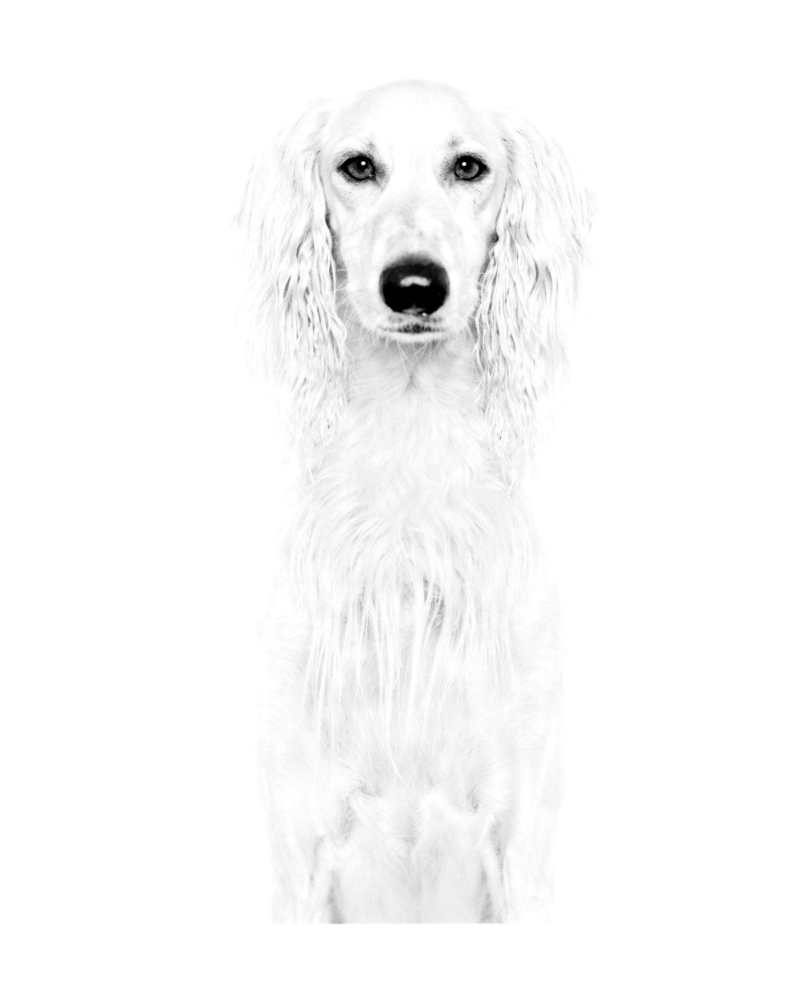

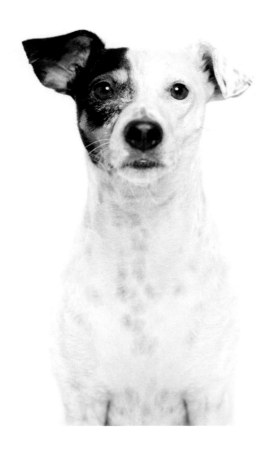

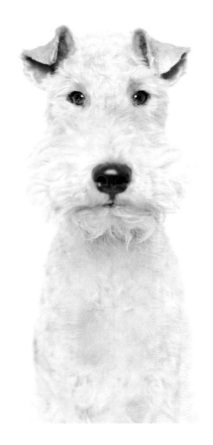

BO
Ratonero Bodeguero Andaluz

BARNIE
Fox Terrier

LAJOS
Saluki

MALI
Malinois

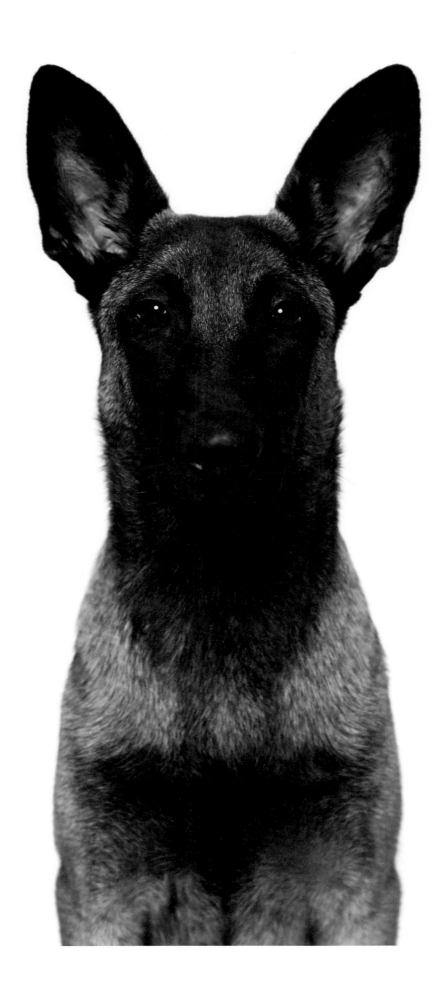

VITANI
Siberian Husky

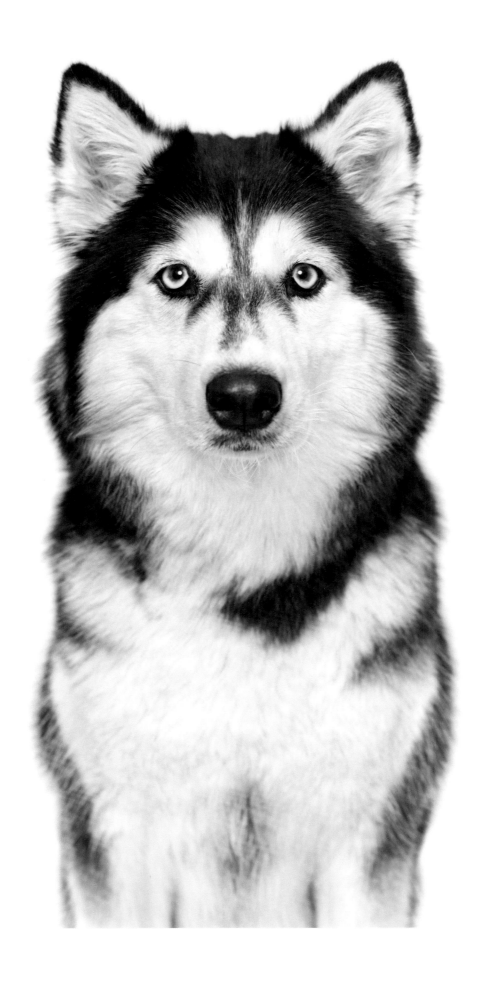

LINUS
Kleiner Münster änder

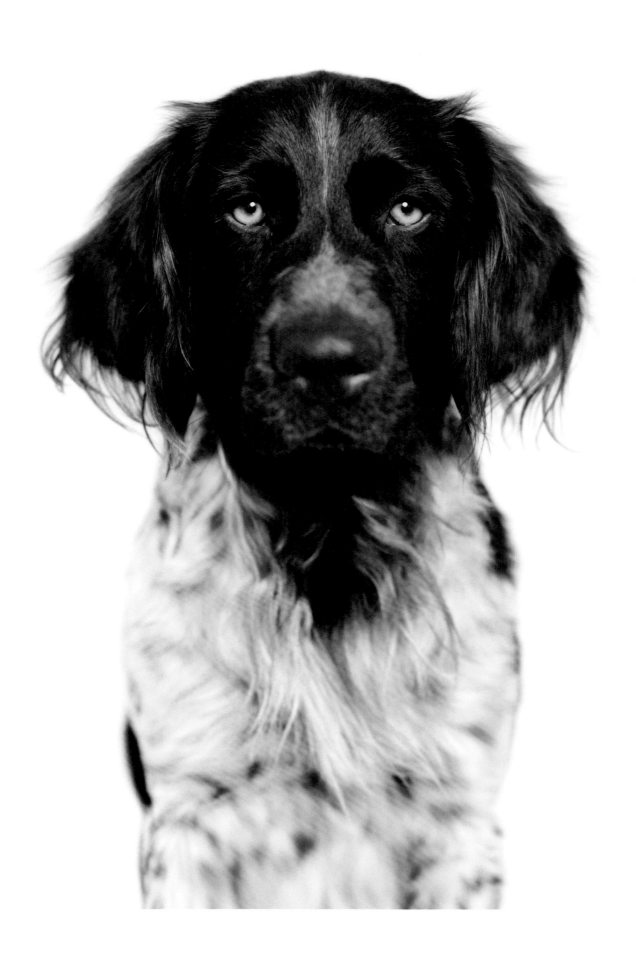

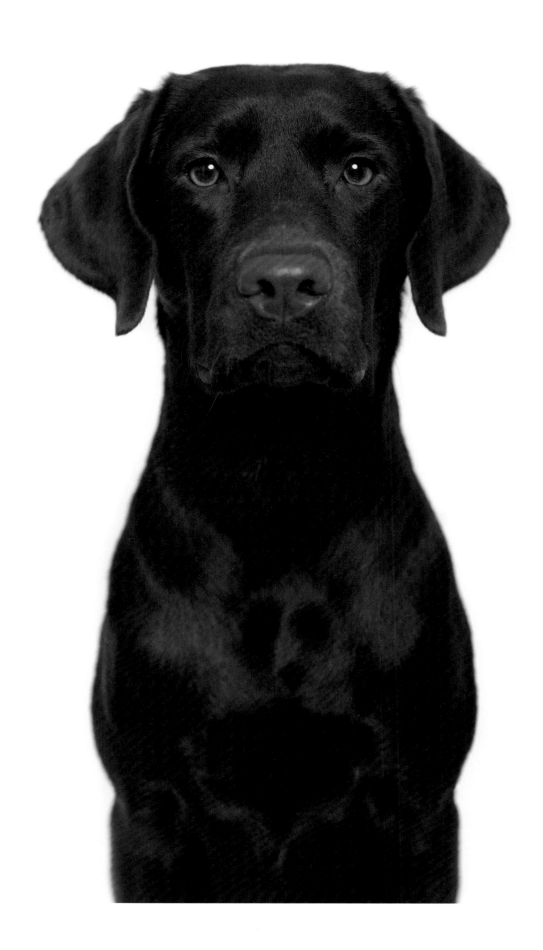

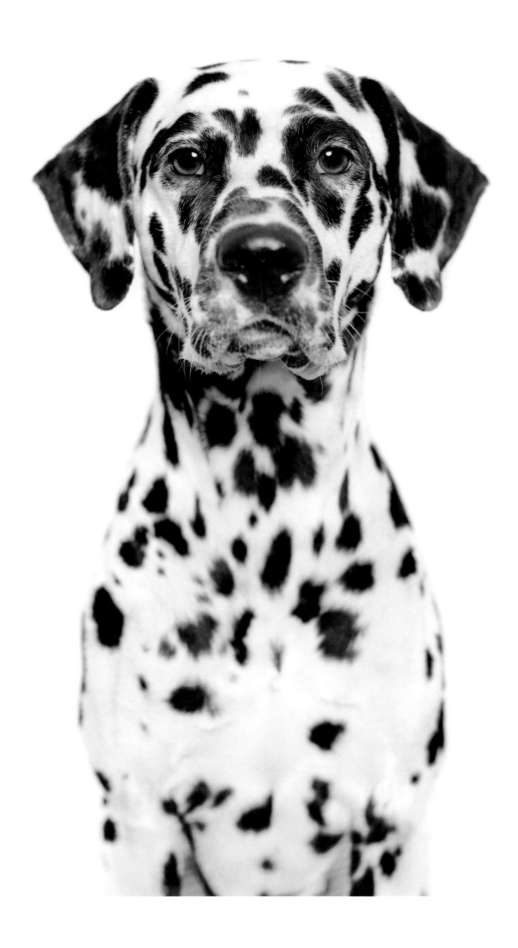

EMMA
Labrador Retriever

ROSA
Dalmatinski llas

EMMI
Australian Cattle Dog Mix

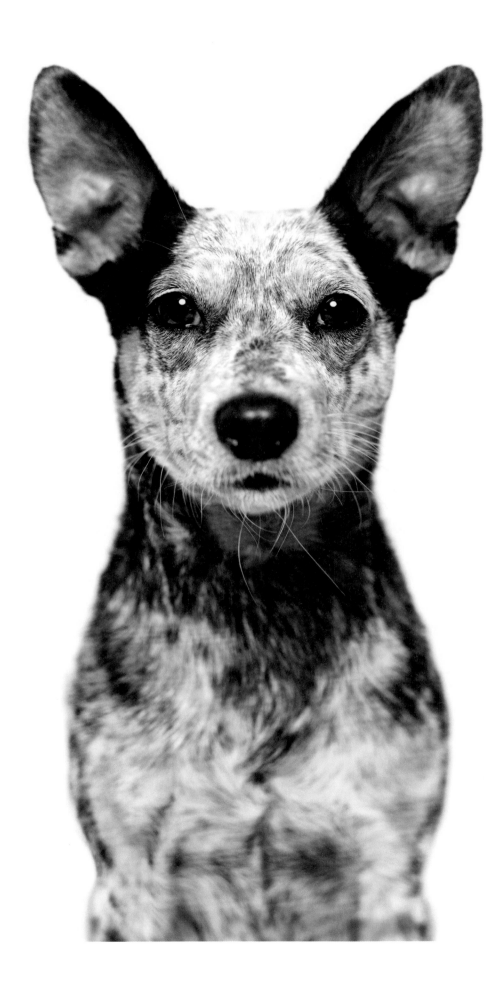

SCHNITZE_
Miniature Bull Terrier

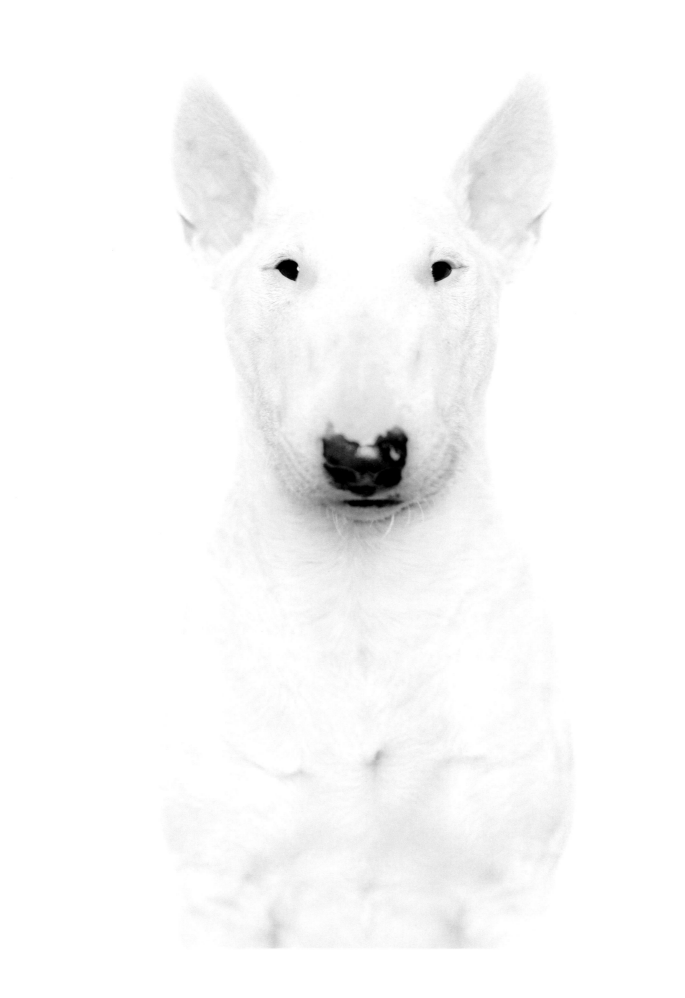

BASHA
Jack Ruessel -Shih Tzu Mix

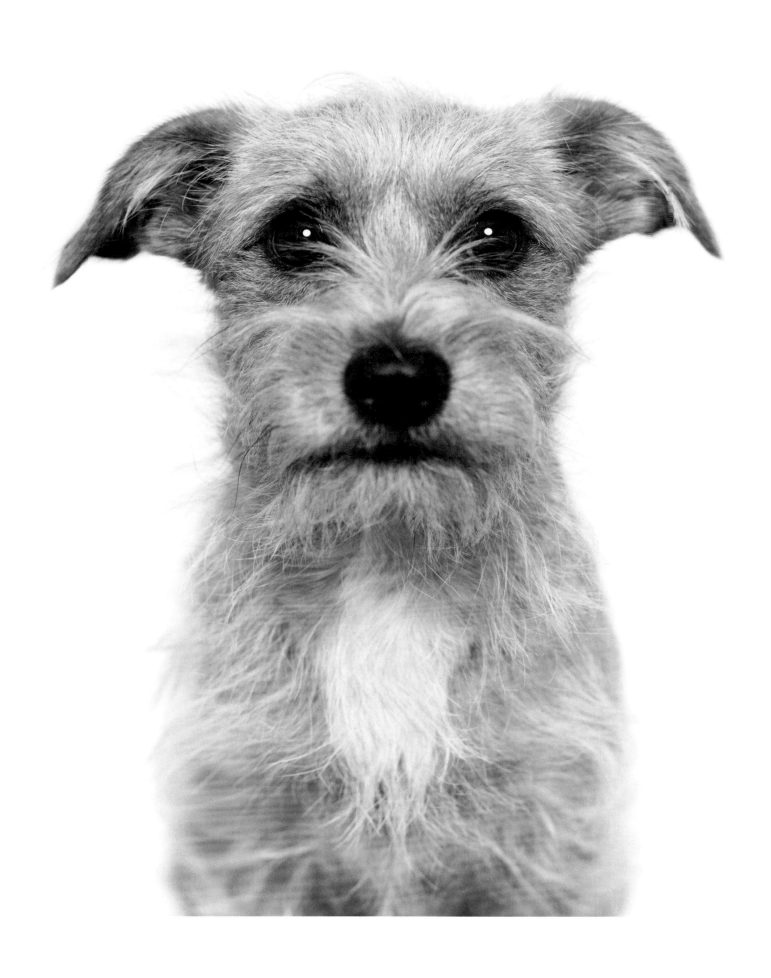

EGON
Pug-Griffon Mix

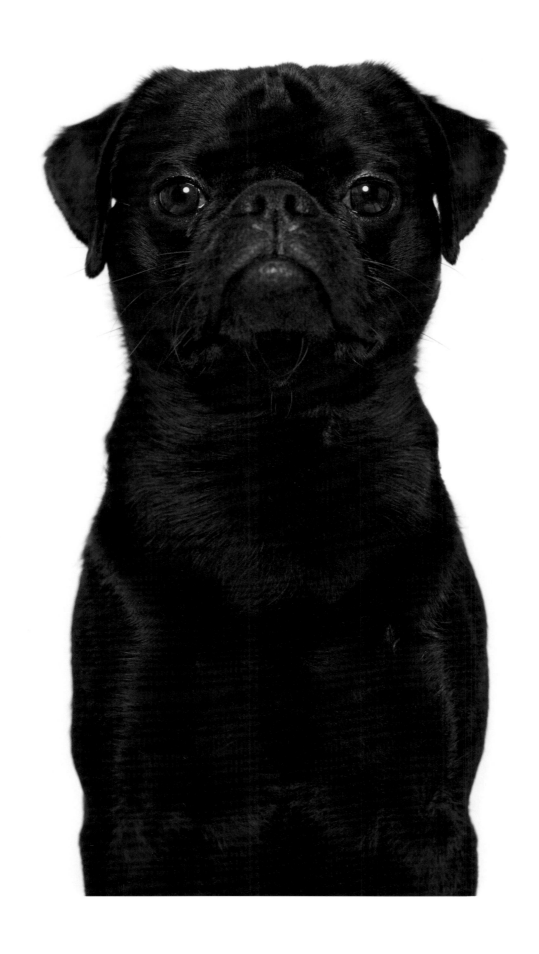

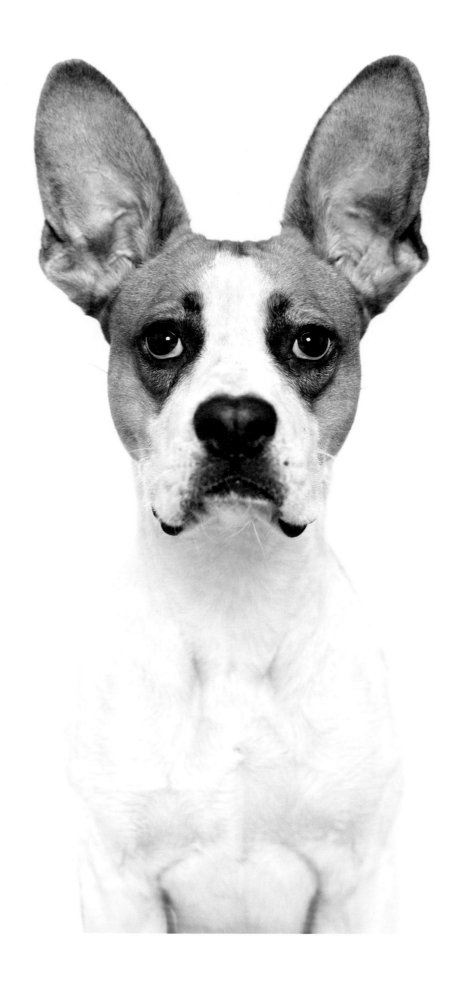

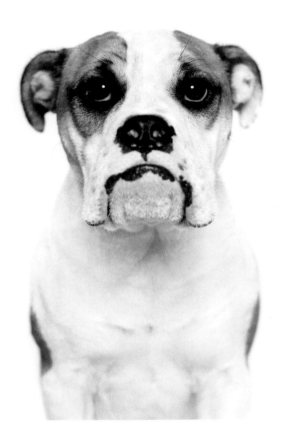

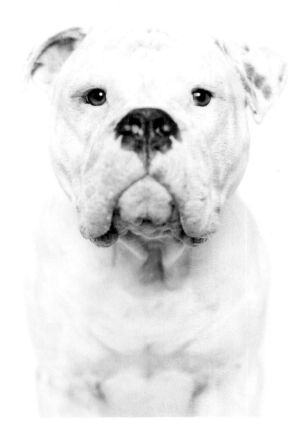

GINO
Continental Bulldog

BEAU
Leavitt Bulldog

BONNIE
Boxer-Shepherd Mix

CHARLY
Basset Hound

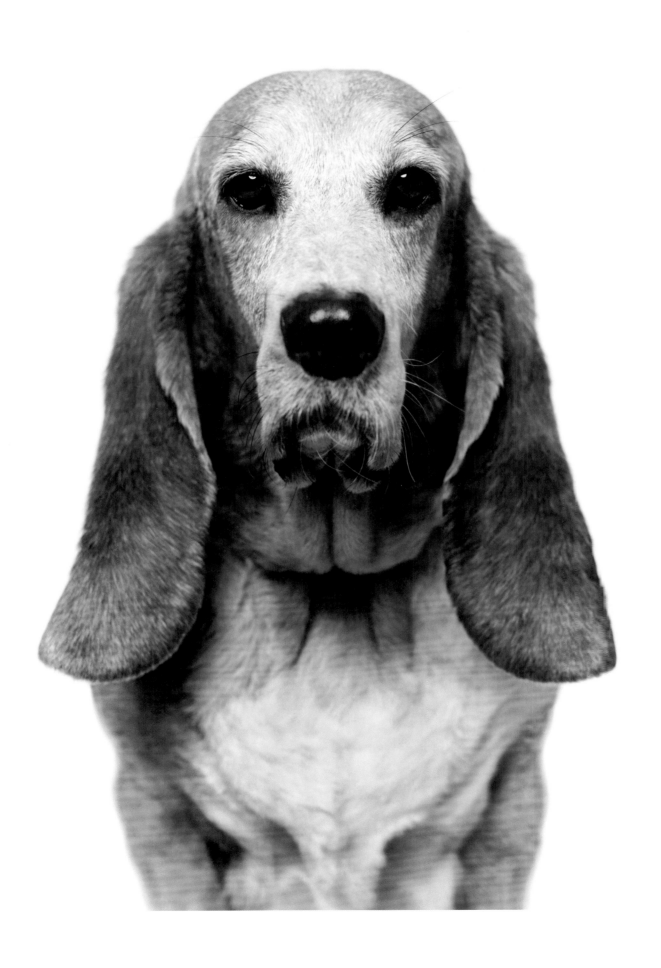

LULA
Mix

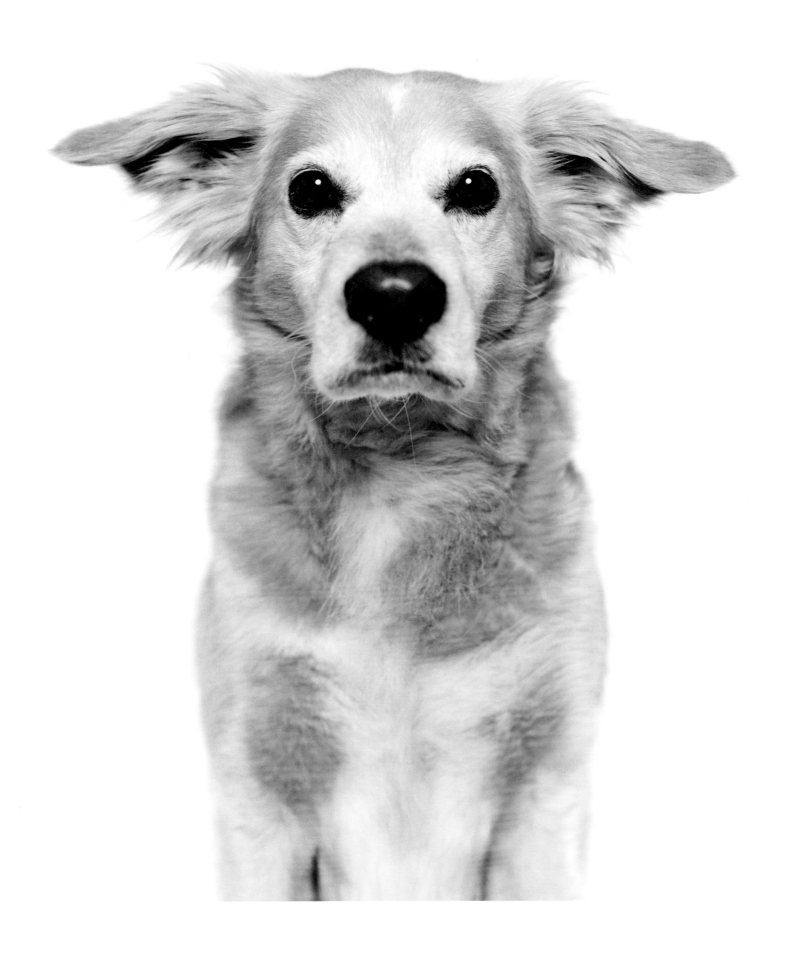

FRIDA
Magyar Vzs ᴈ Mix

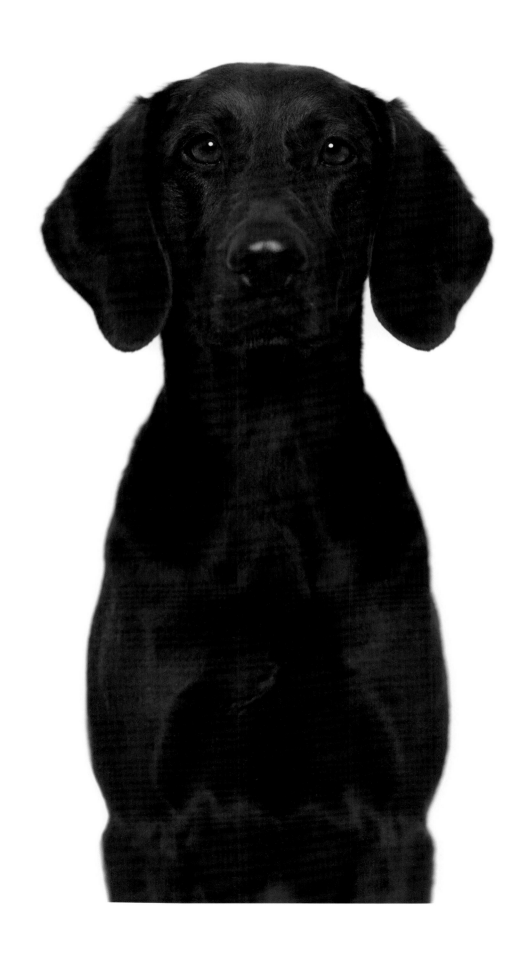

NASKO
Airedale Ter er

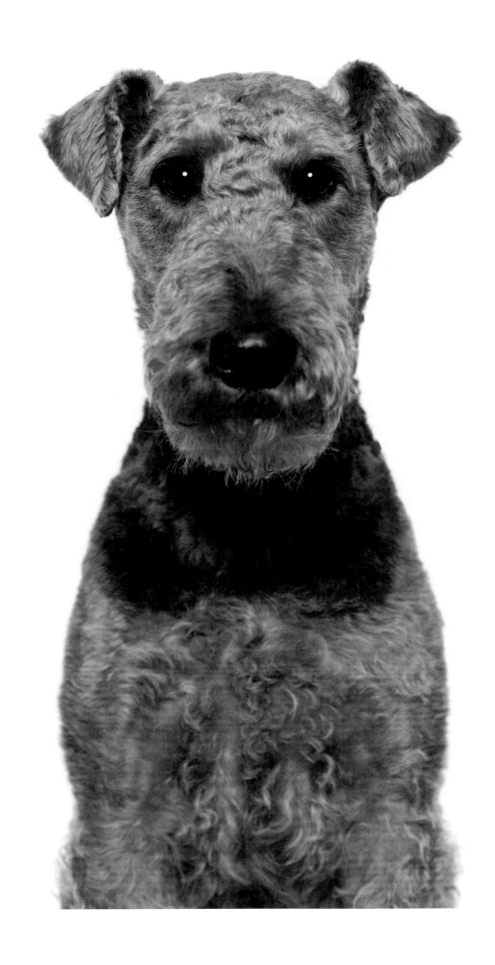

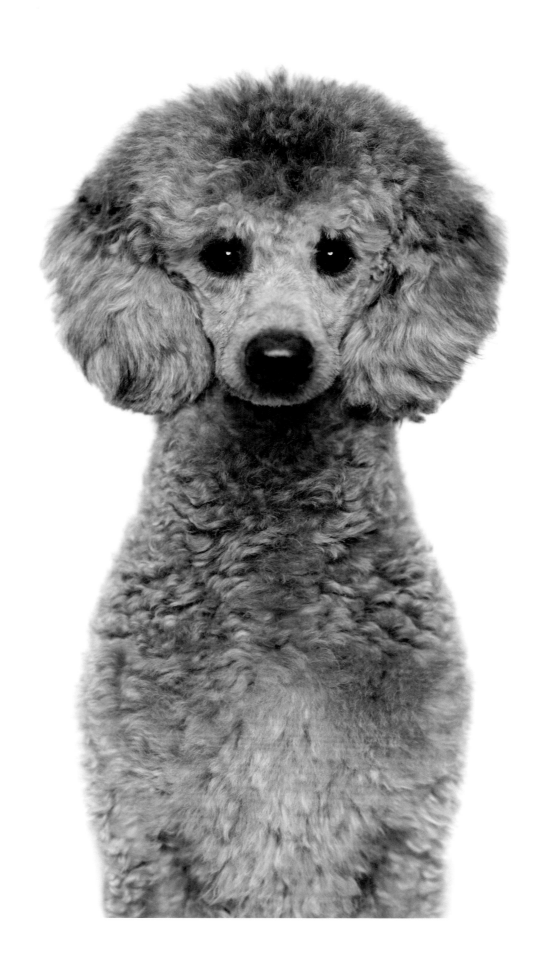

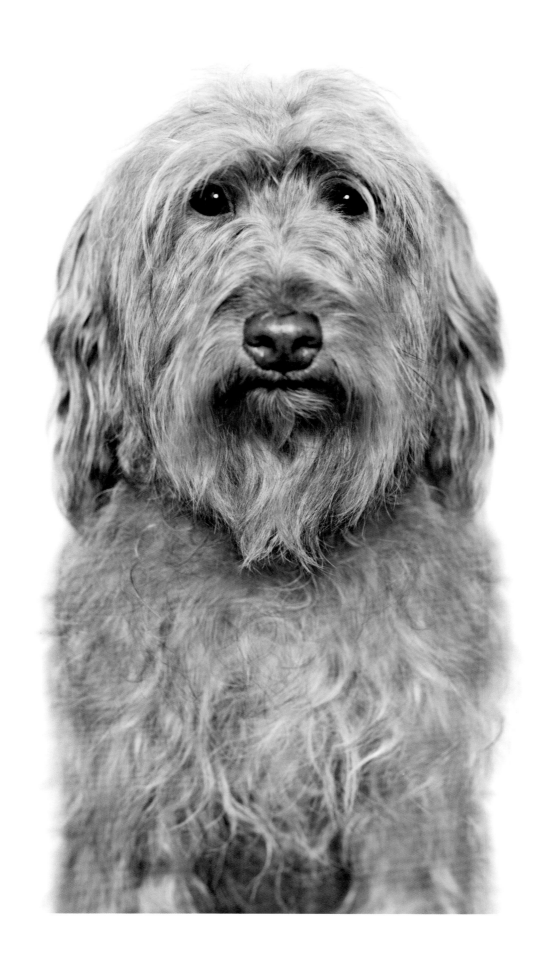

COONI
Caniche Moyen

TAXI
Perro de Agua Español Mix

DAIZY
Miniature Australian Shepherd

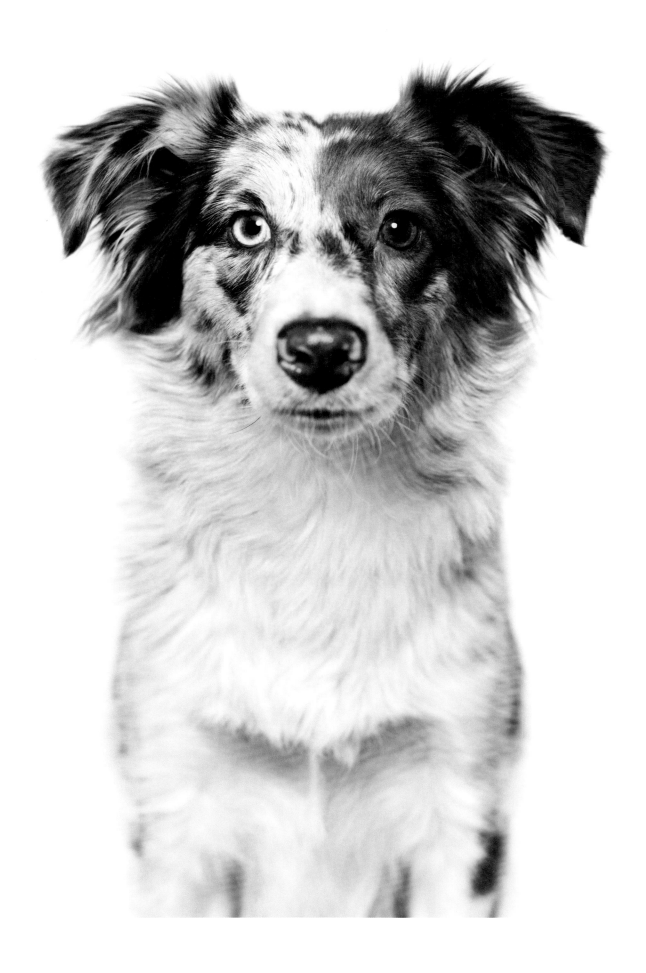

BAKARI
Azawakh

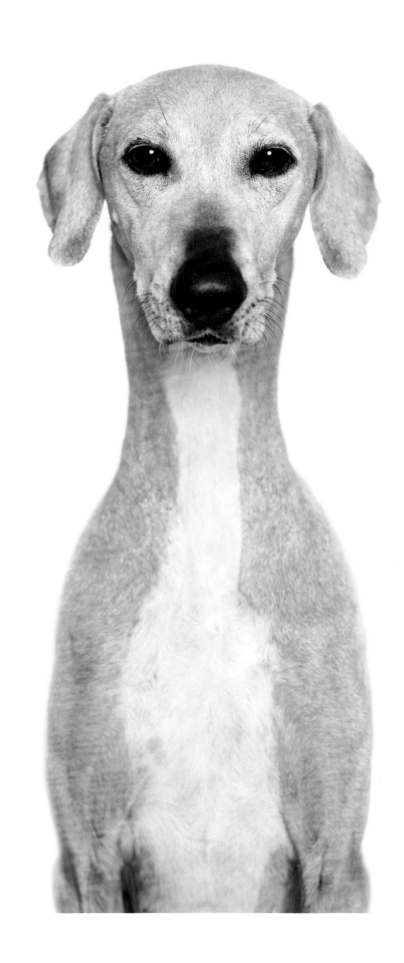

MOGLI
Podenco–Bull Terrier Mix

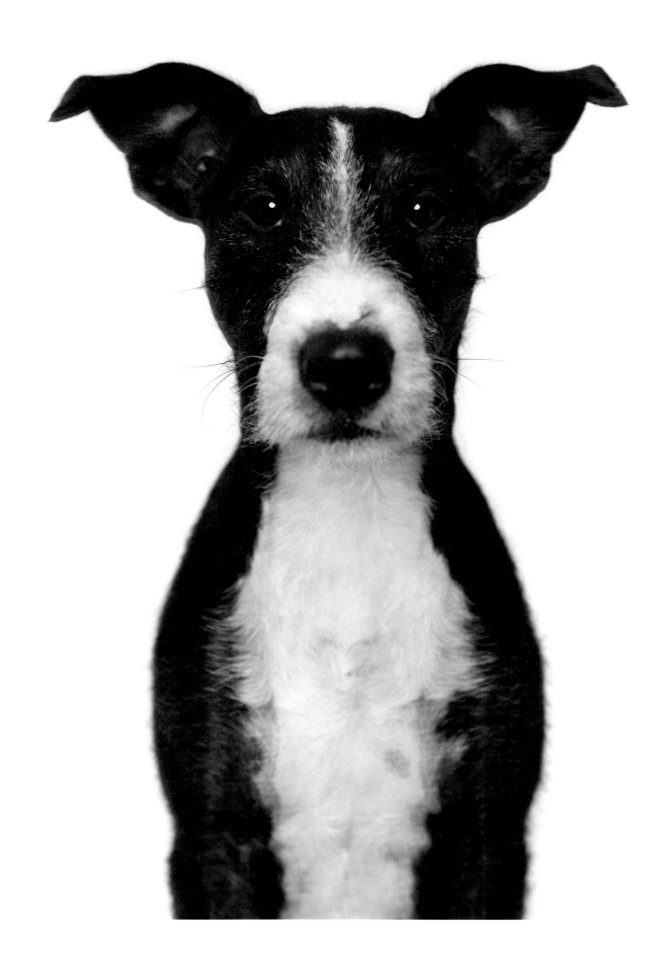

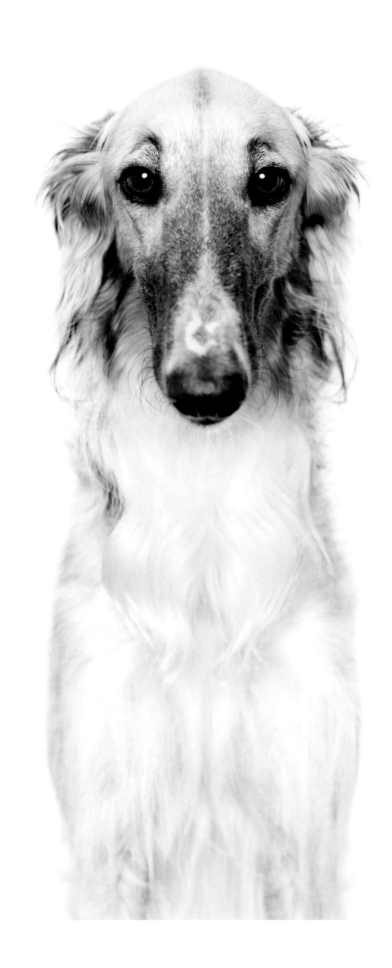

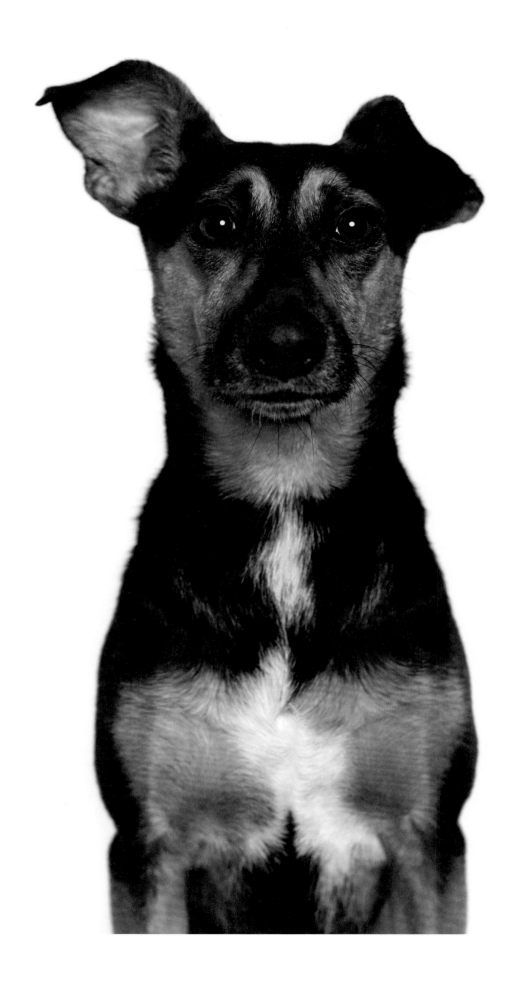

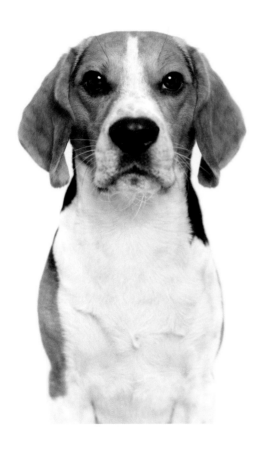

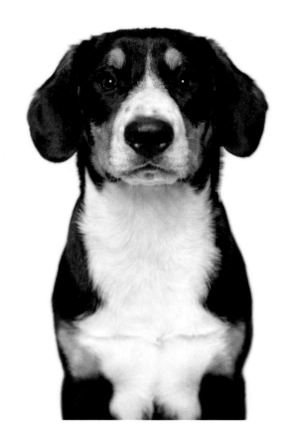

SPIKE
Beagle

HUTCH
Entlebucher Sennenhund

PFIEPS
Dobermann Mix

CASSIA
Deutscher Pinscher

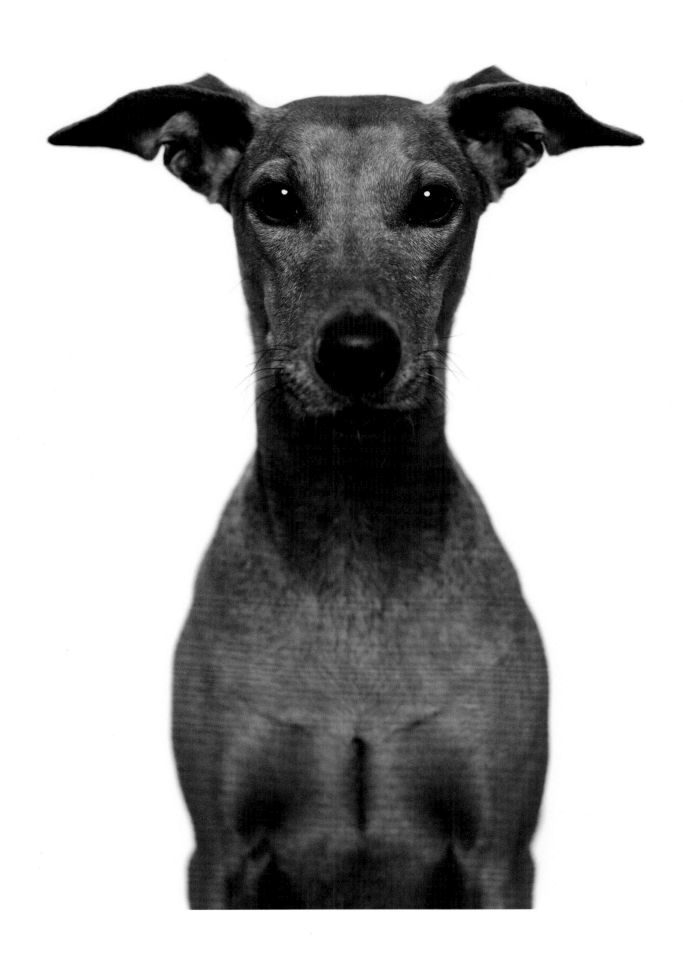

BEN
Berger Blanc Suisse

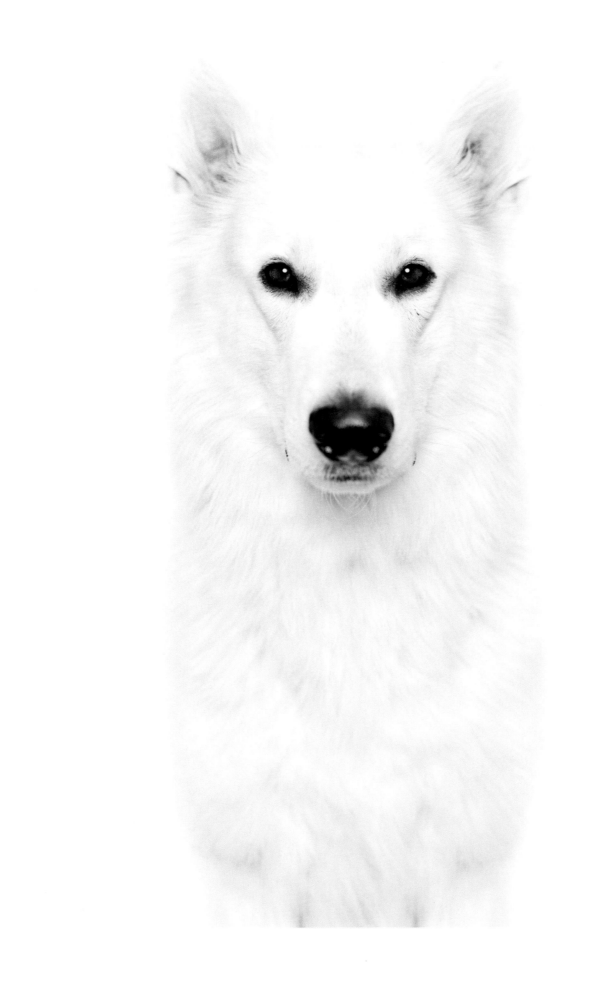

LIA
Rövidszőrű Magyar Vizsla

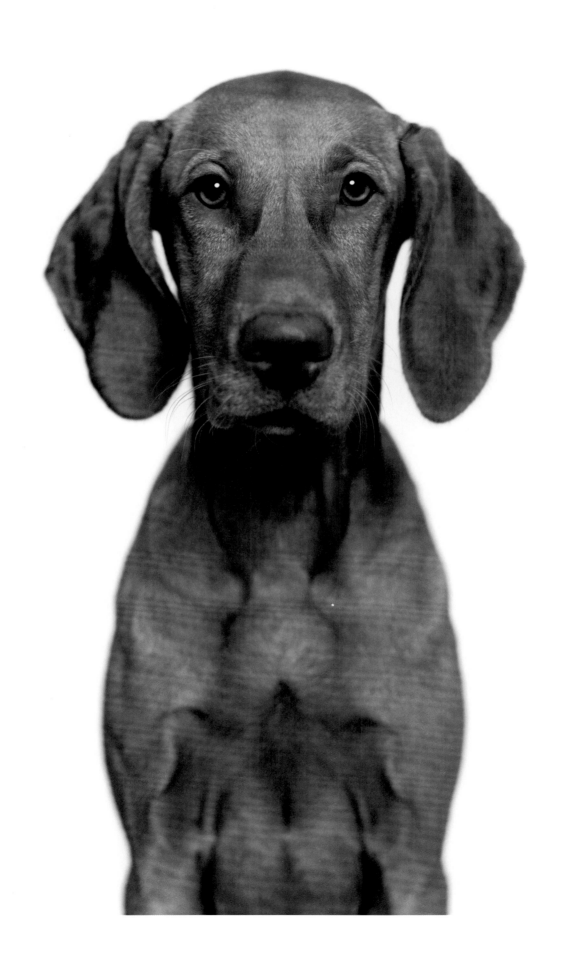

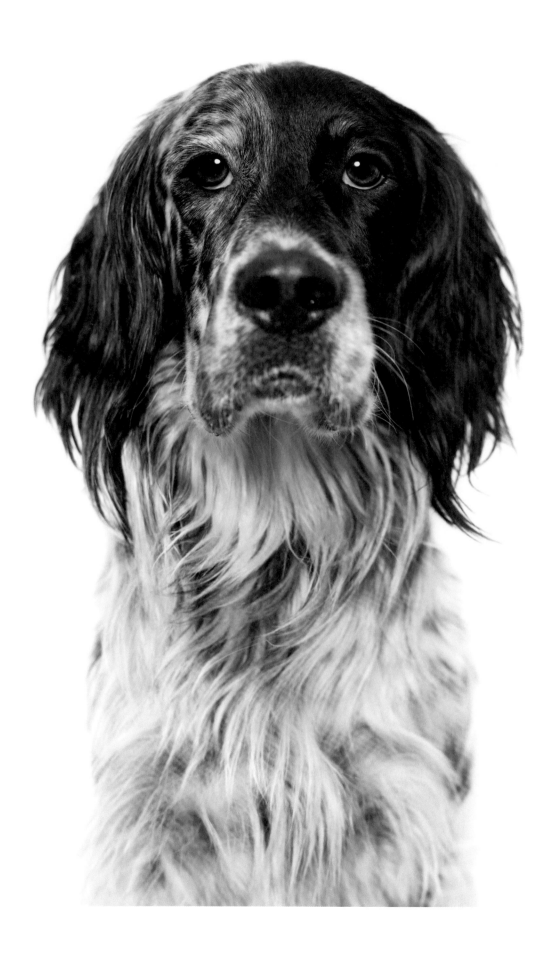

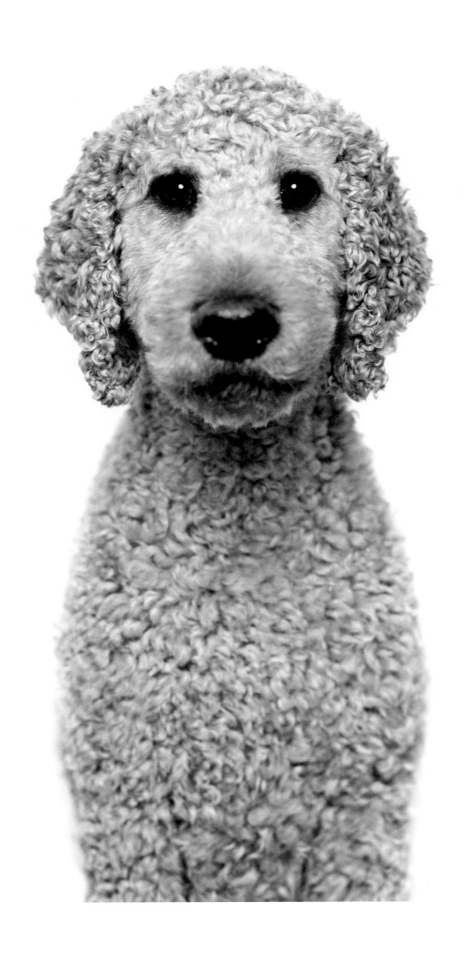

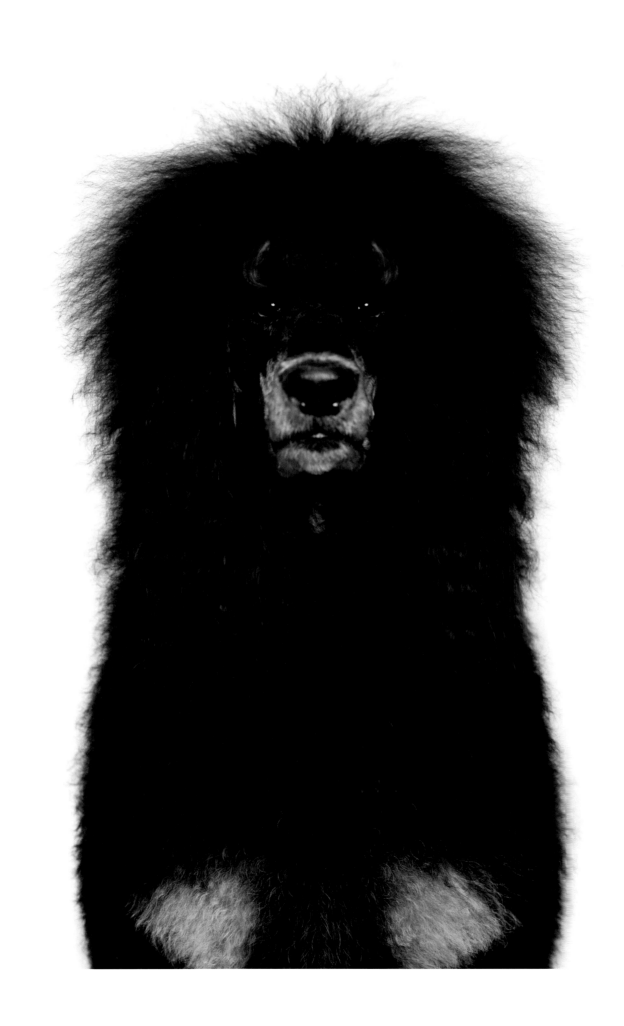

ELMAR
Grand Ca■ ⊃⊒

BOBBY
Grand Ca■ ⊃⊒

MIRA
Kelb tal-F■n■⊂ Mix

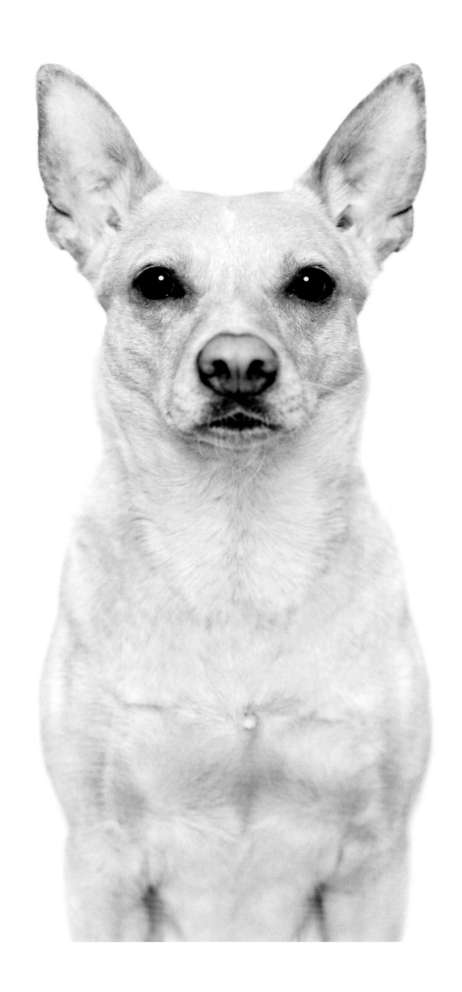

AYUBA
Chinese Crested Dog

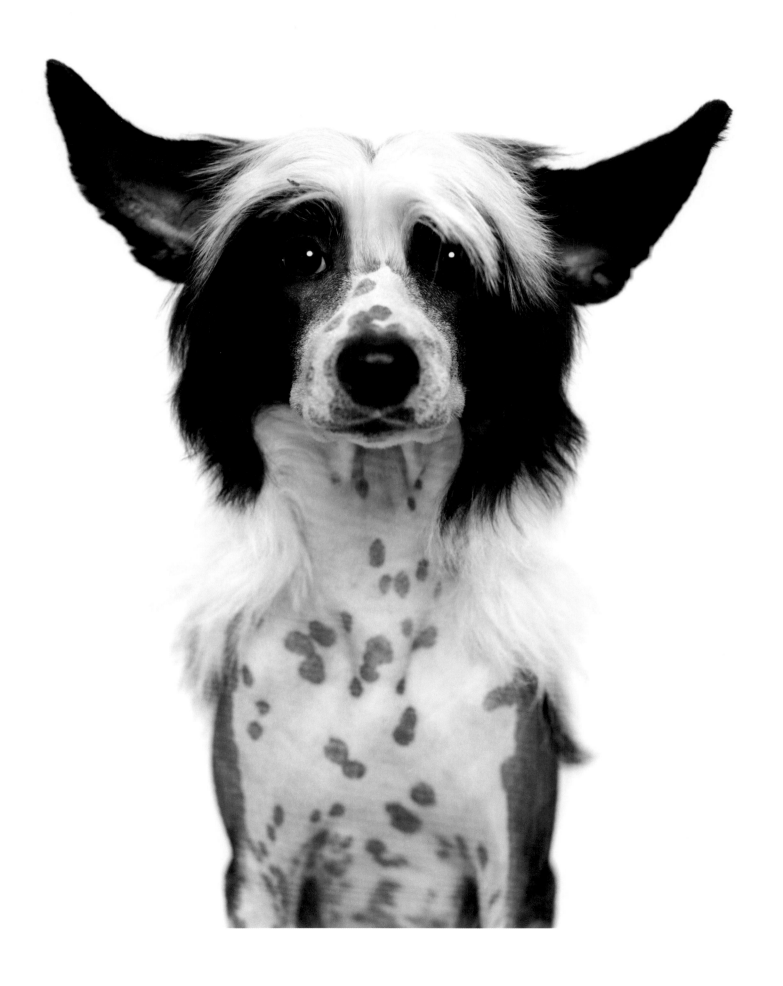

SHIWA
Deutsch Kurzhaar Mix

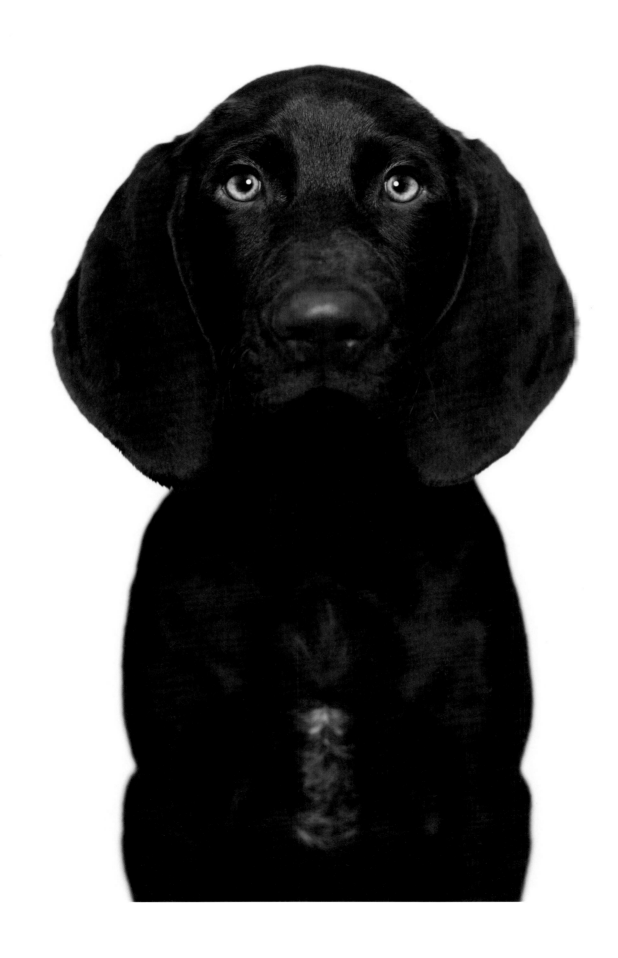

ERWIN
Bouledogue français

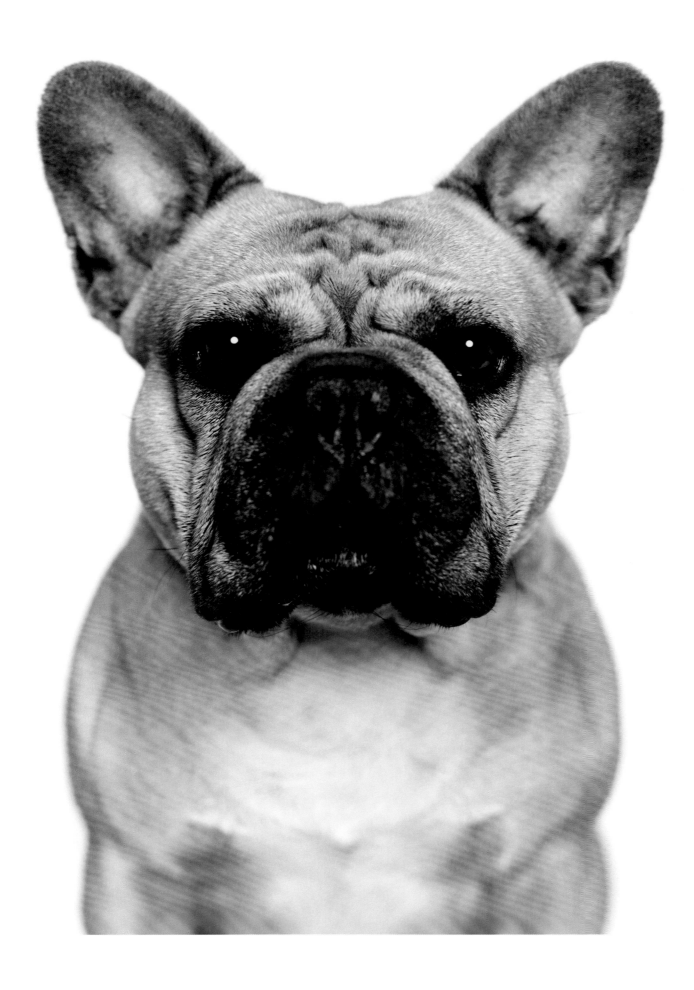

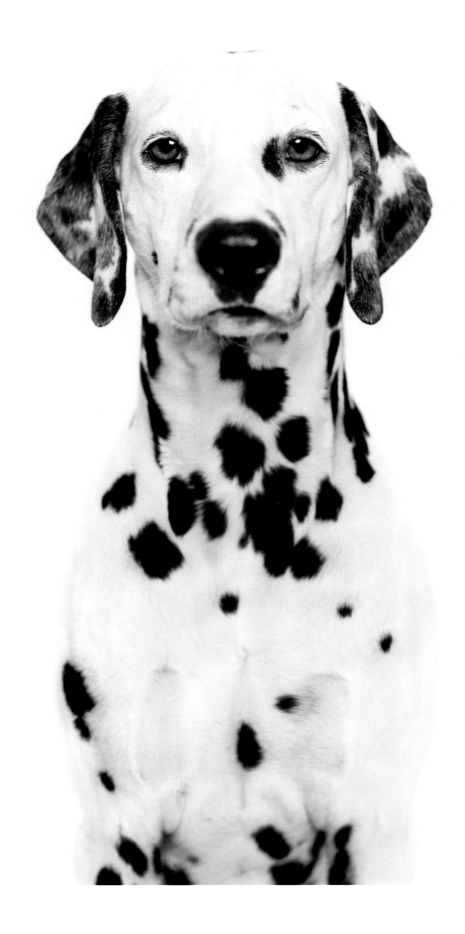

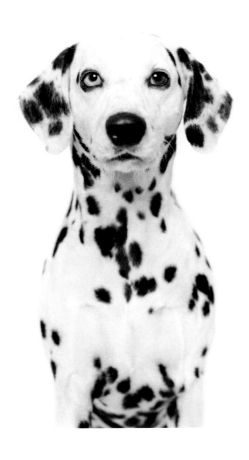
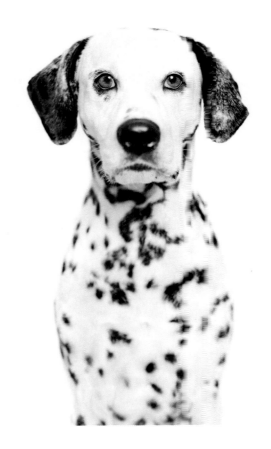

AYUMI
Dalmatinski Pas

KIRA
Dalmatinski Pas

JAMIE LYNN
Dalmatinski Pas

LOUIS
Pug

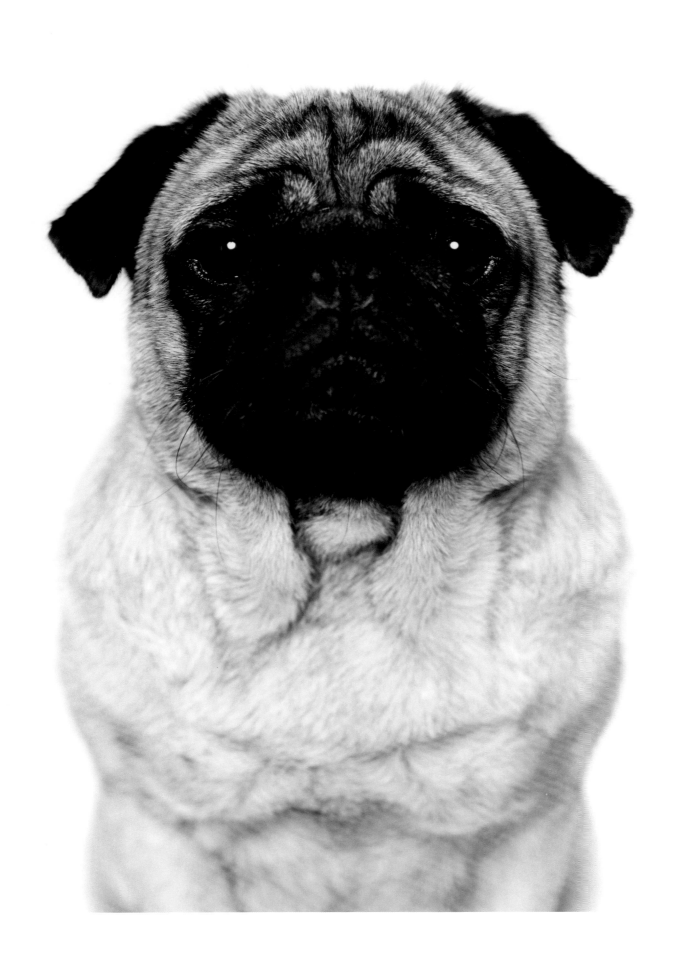

EMMA
English Springer Spaniel

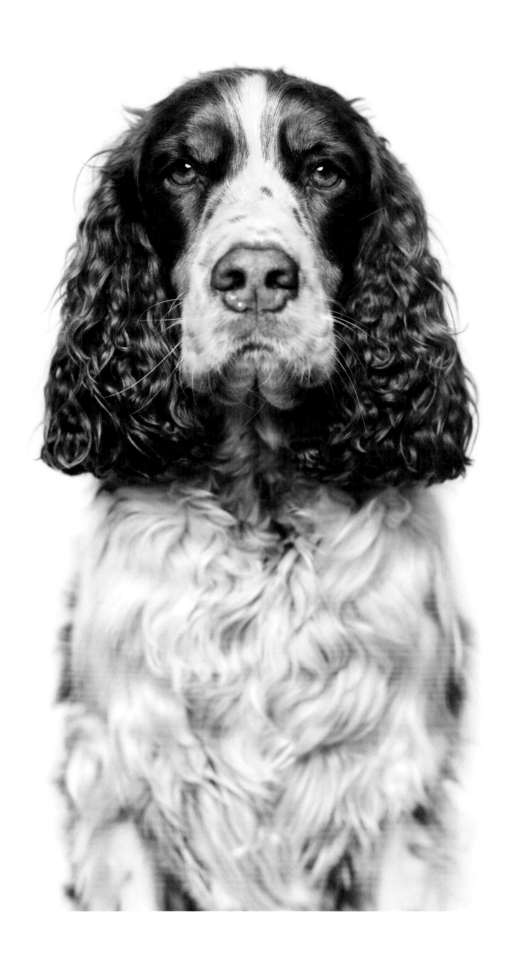

DINO
Mix

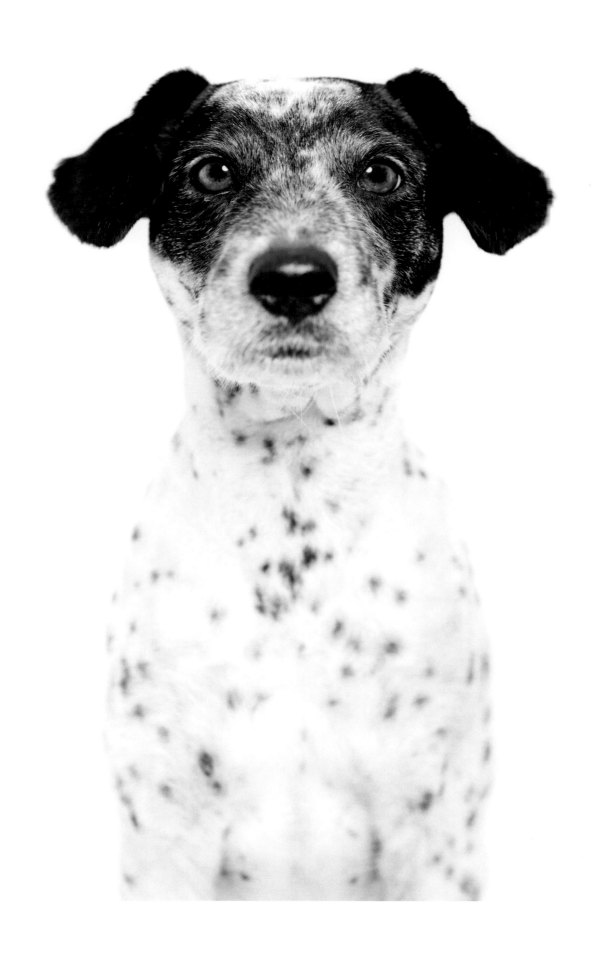

CHILI
Spitz Mix

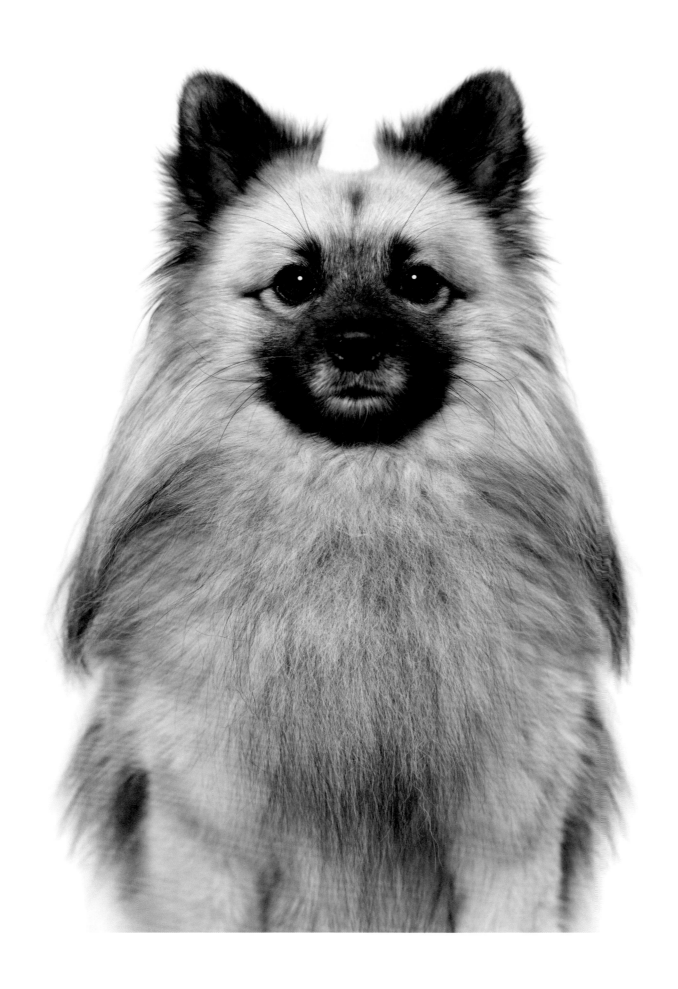

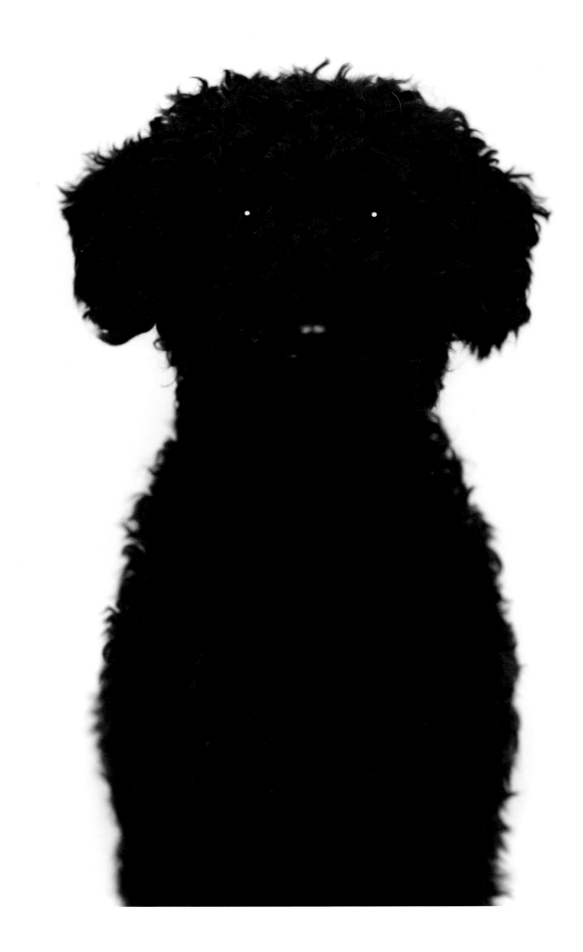

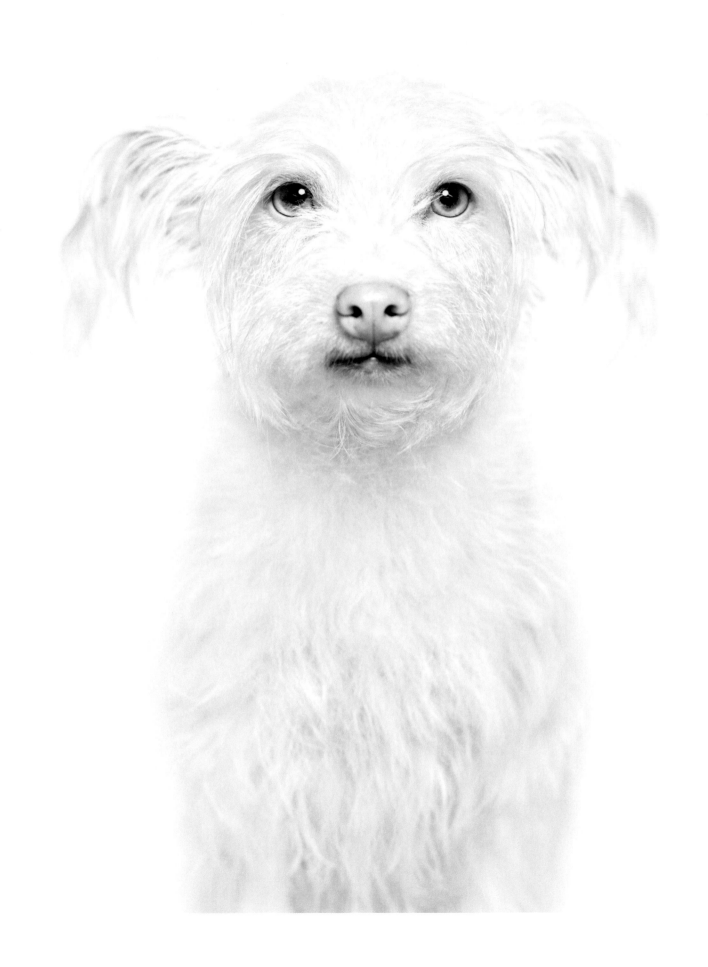

PULI
Puli Mix

PIPA
Podenco Mix

HJALTE
Drótszőrű Magyar Vizsla

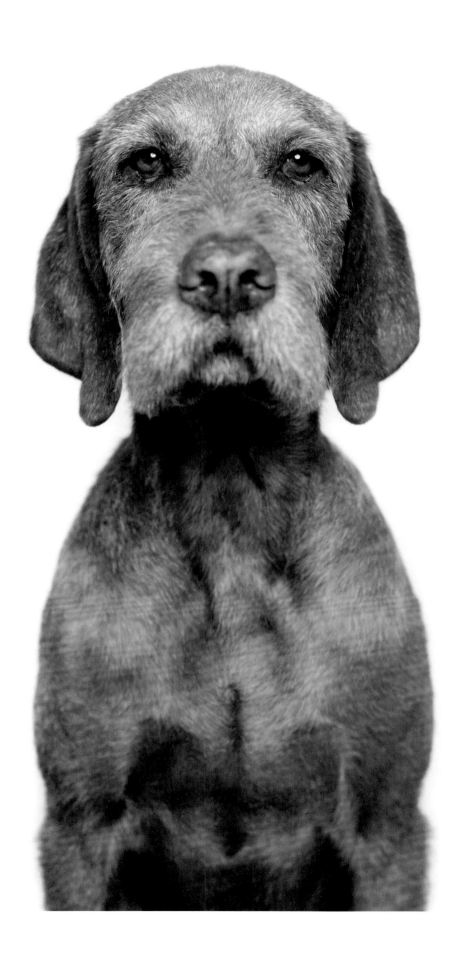

QUENZO
Piccolo Levriero Italiano

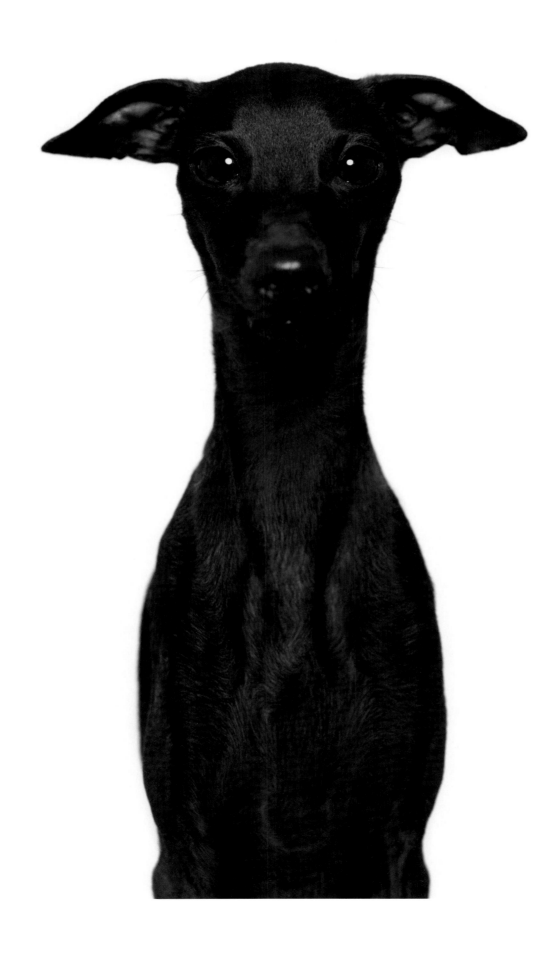

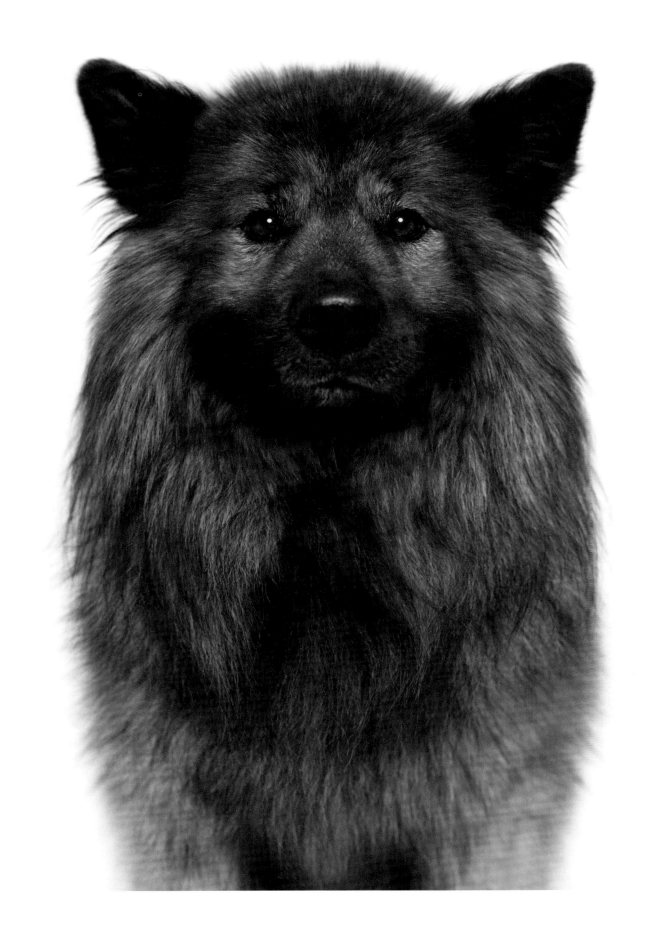

LANTEY
Borzoi

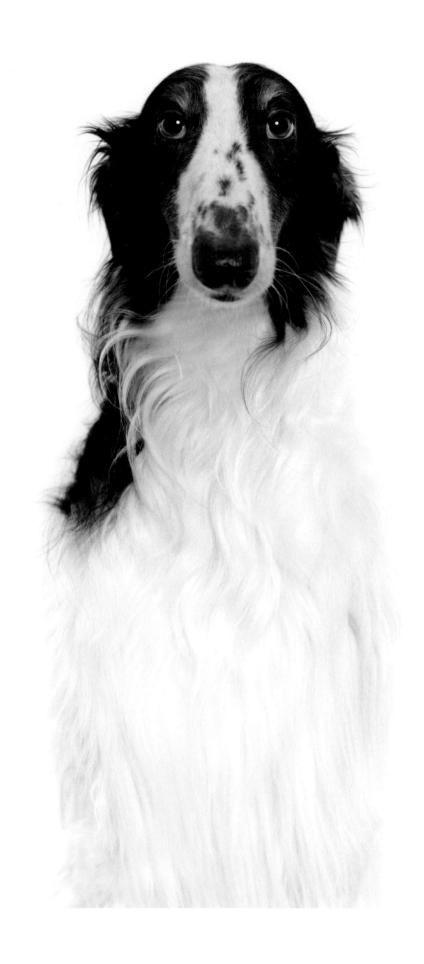

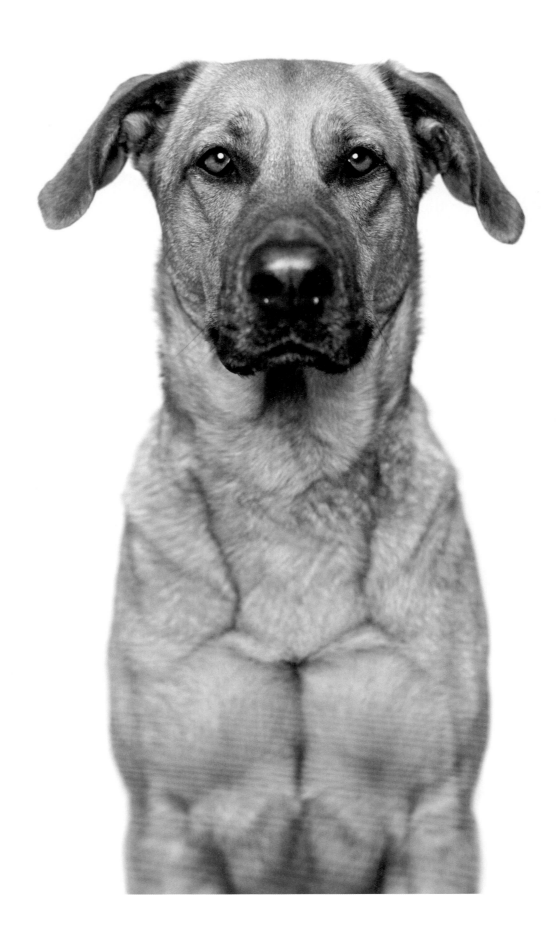

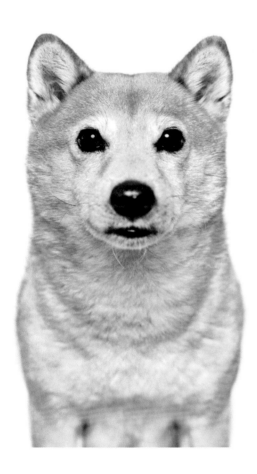

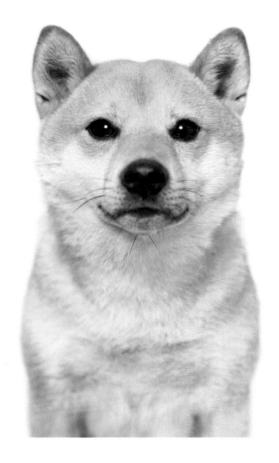

AKI
Shiba Inu

JIRO
Shiba Inu

MIRA
Mix

KURTIS
Elo

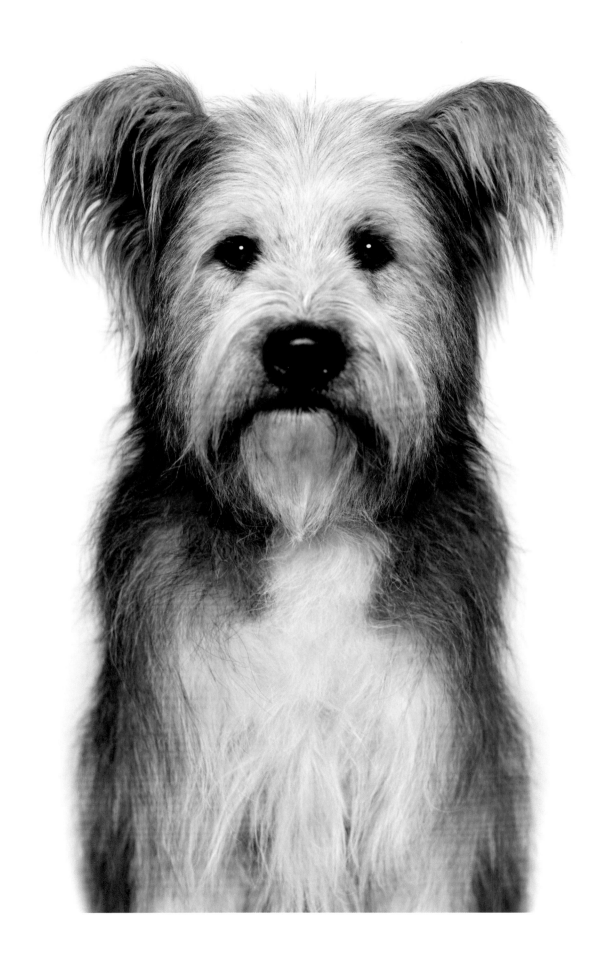

BONJI
Basenji

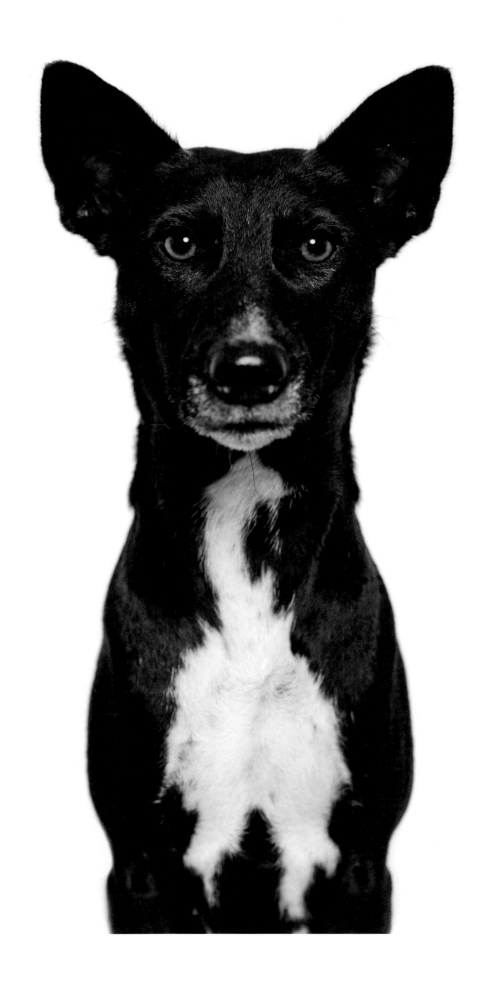

BATTISTA
Bracco Italiano

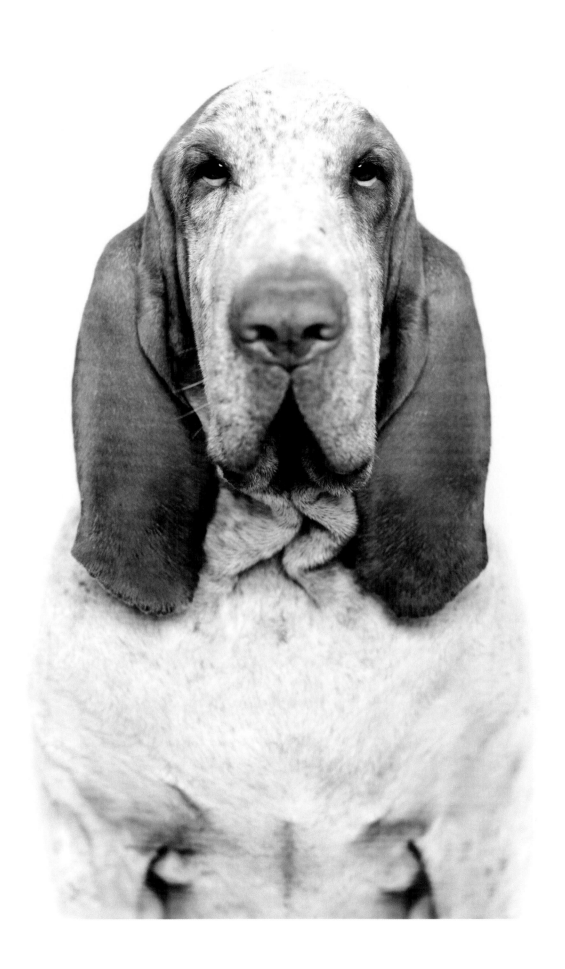

AMANDA
Siberian ▌sky

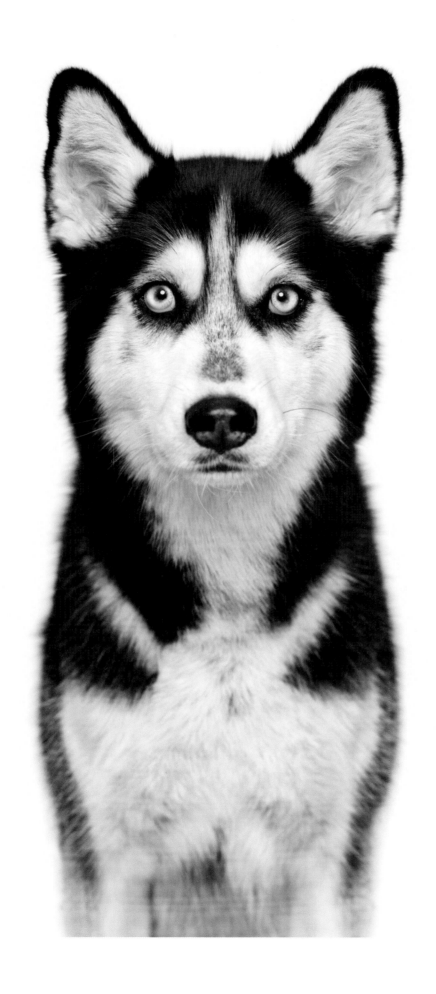

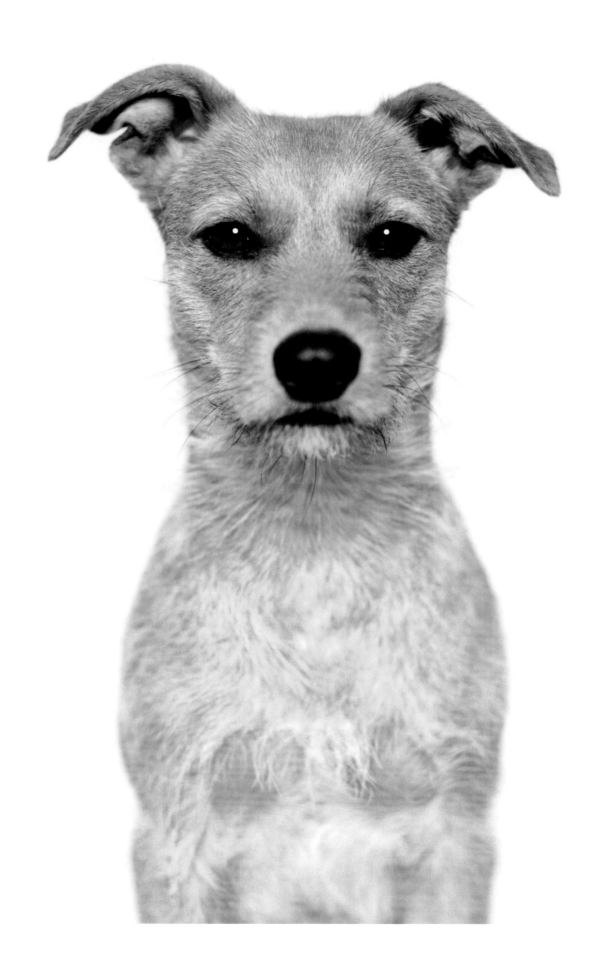

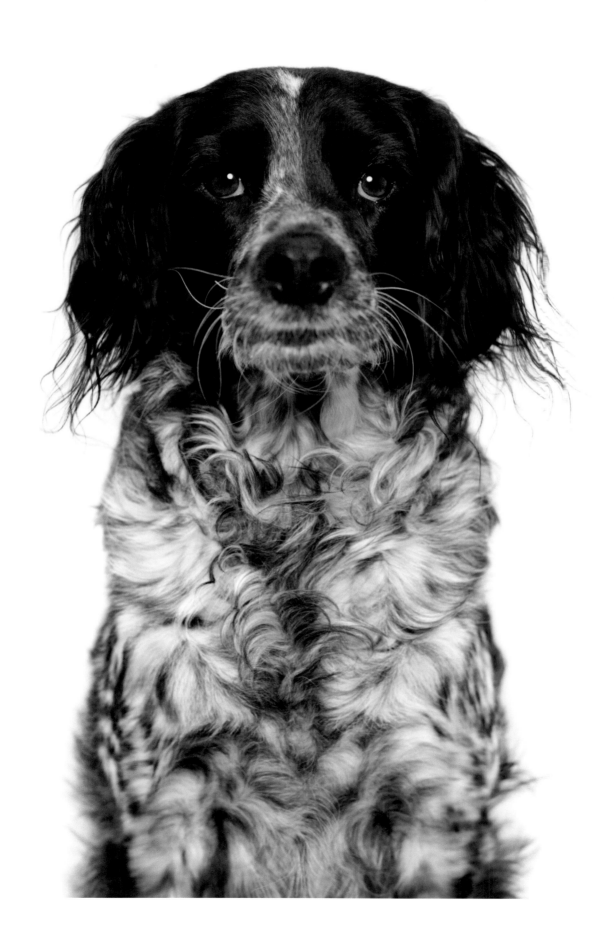

MATA HARI
Mix

STELLA
Epagneu Breton

MIA
Deutsche Dogge

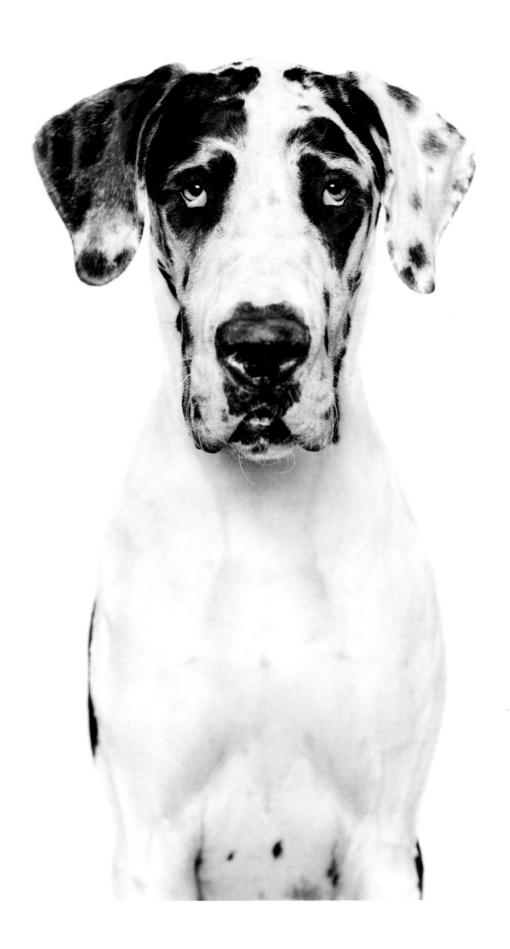

CARLOS
Doberman

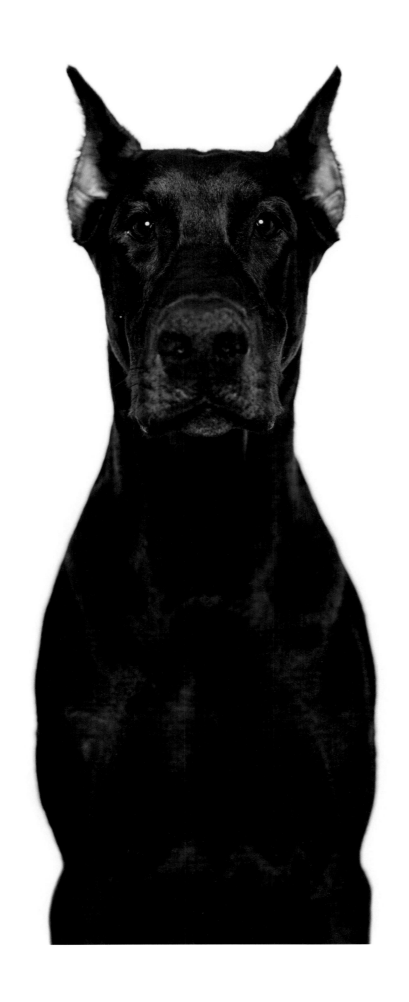

LANA
Husky-Federico Mix

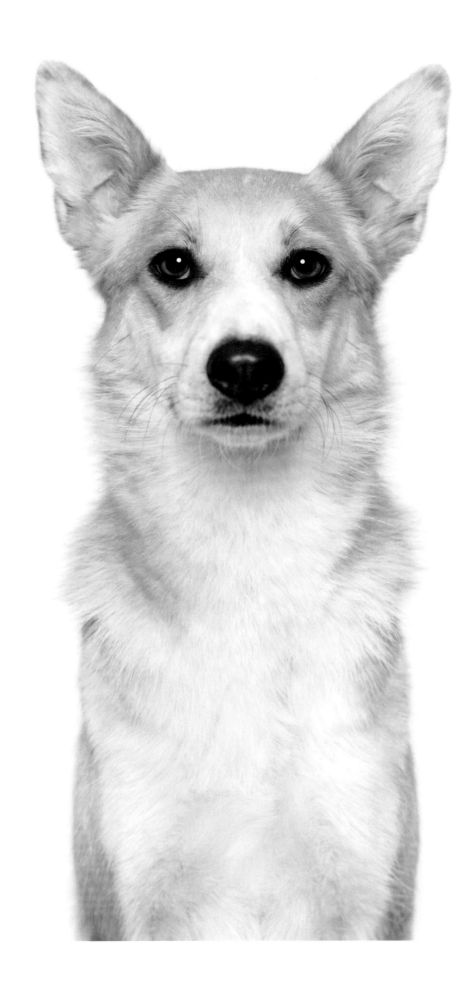

LILA
Australian Shepherd

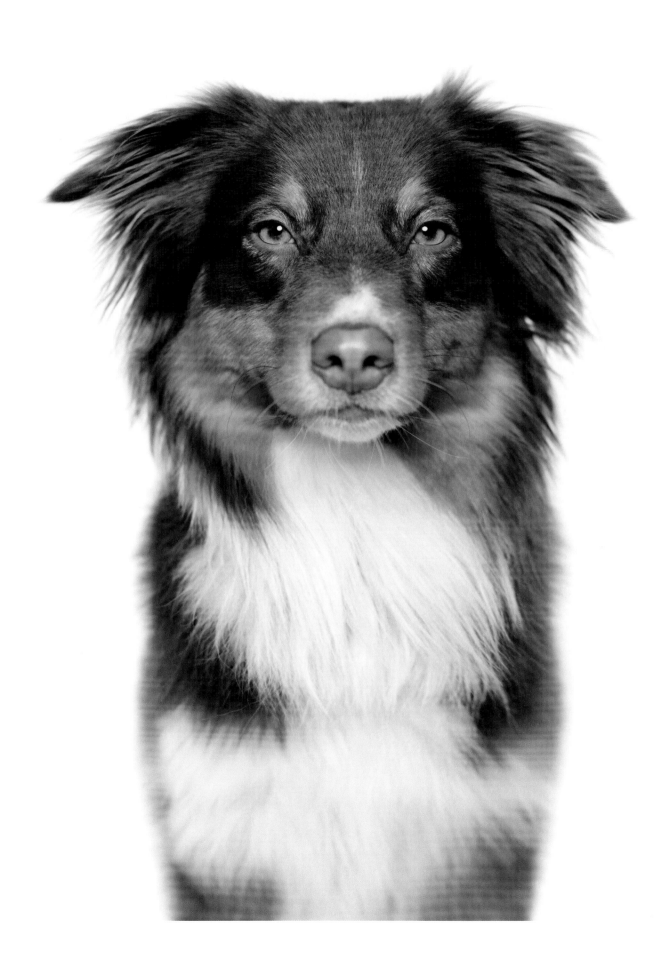

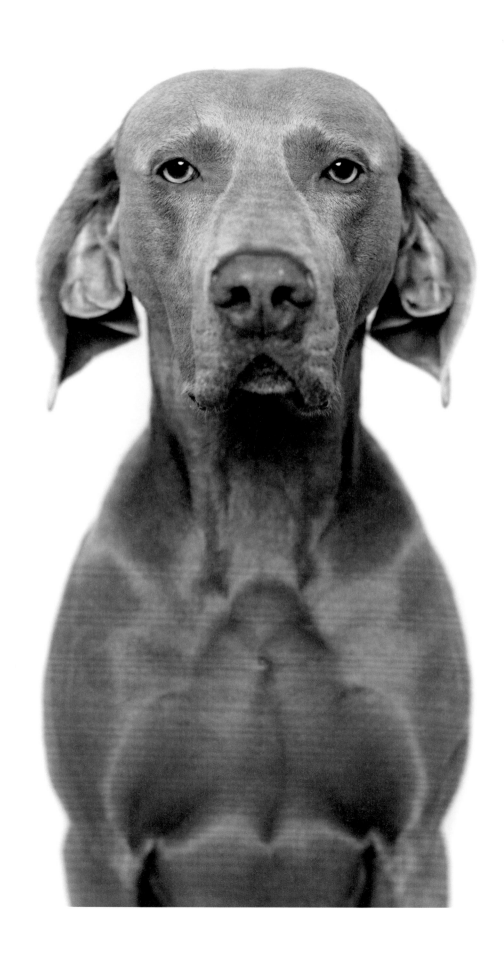

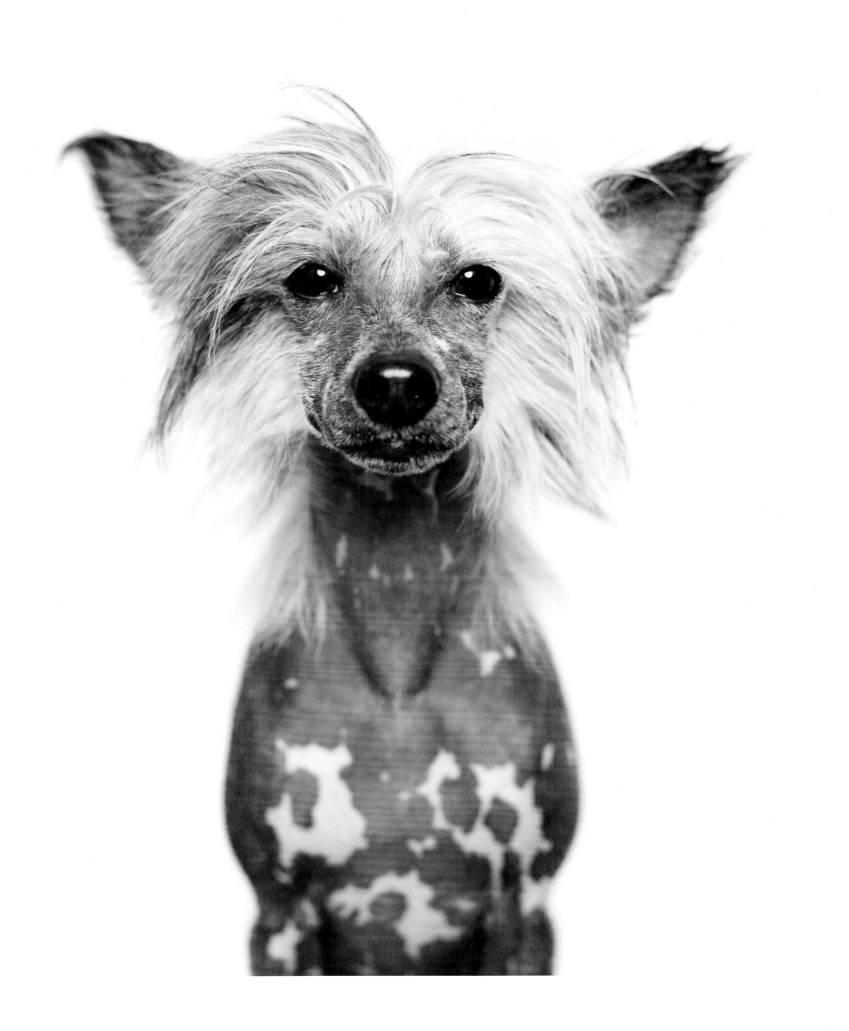

JAMES SILVER
Weimaraner

JUNIOR
Chinese Crested Dog

JOSCHI
English Cocker Spaniel

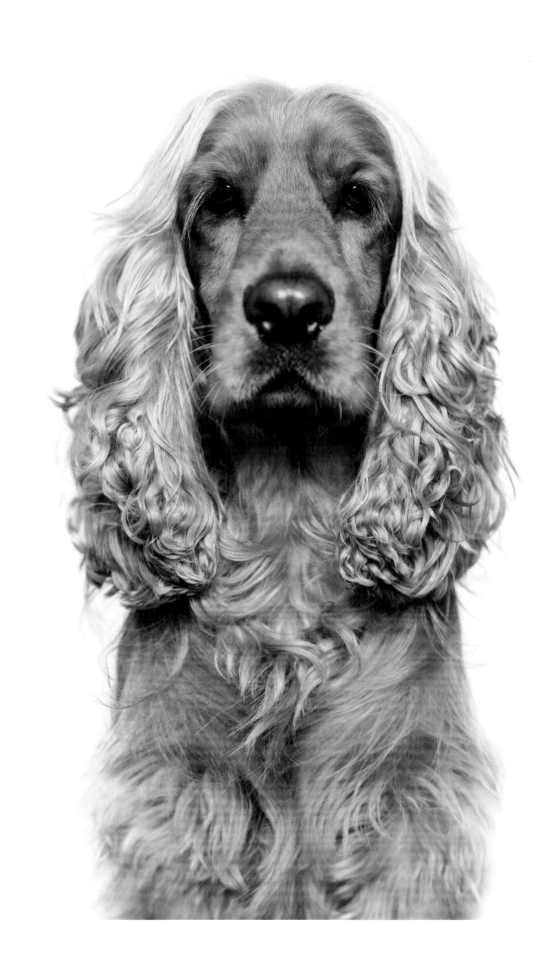

COOKIE
Schnauzer-Se⁼er Mix

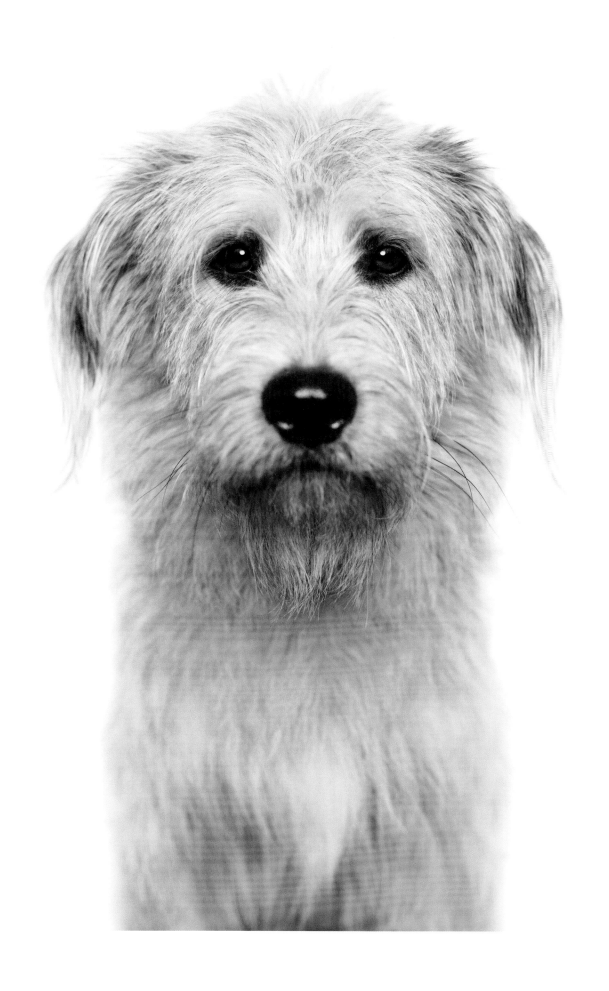

IRA
Mix

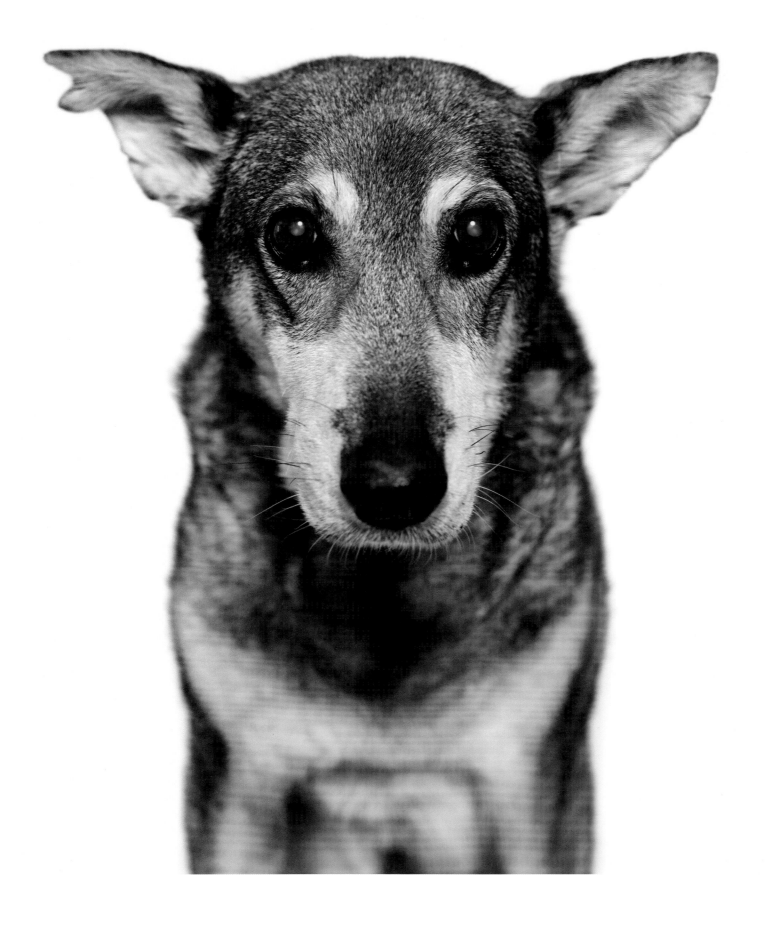

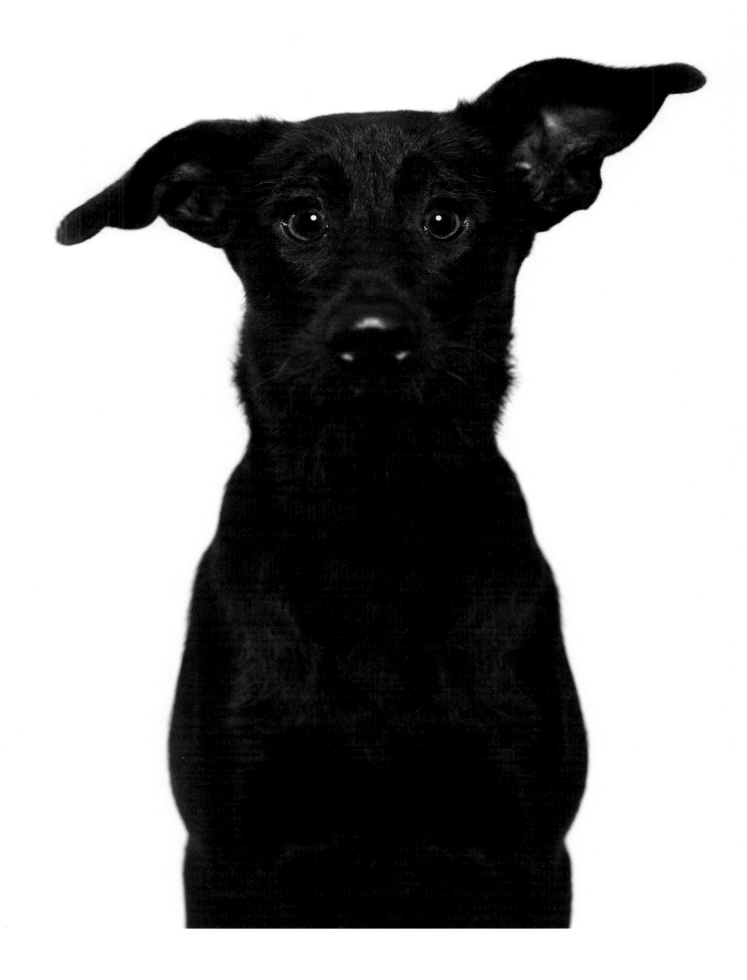

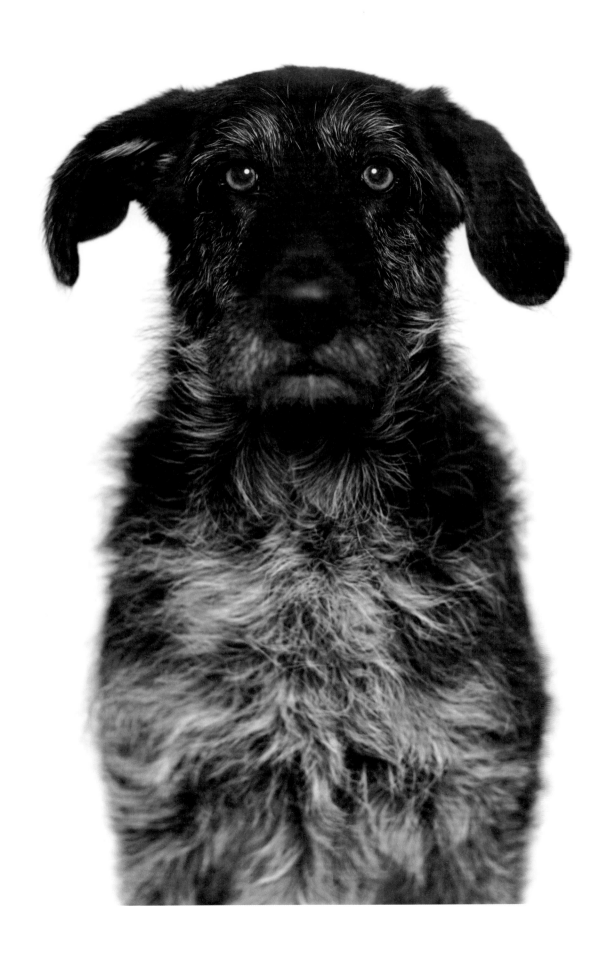

PEPPY
Schnauzer-Labrador Mix

KIRA
Labradoodle

JESSI
Kangal

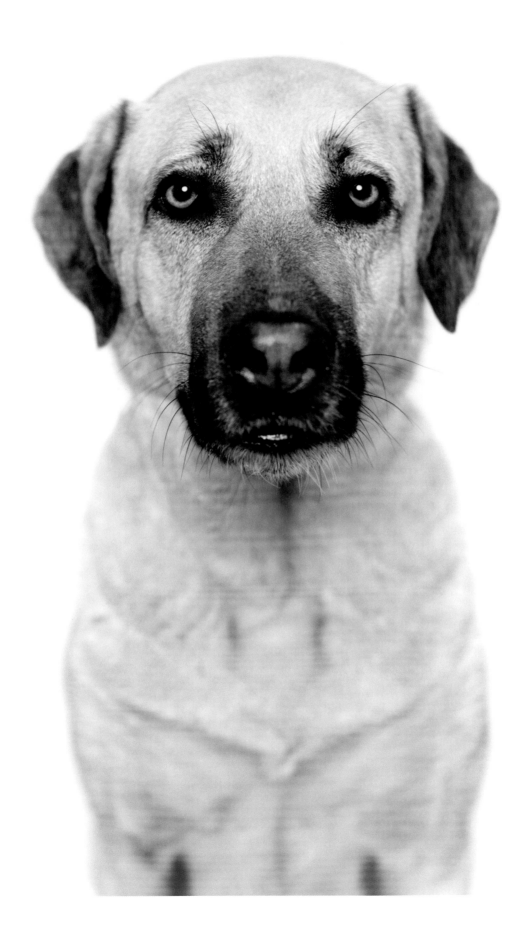

HAKU
Boxer-Staffordshire Mix

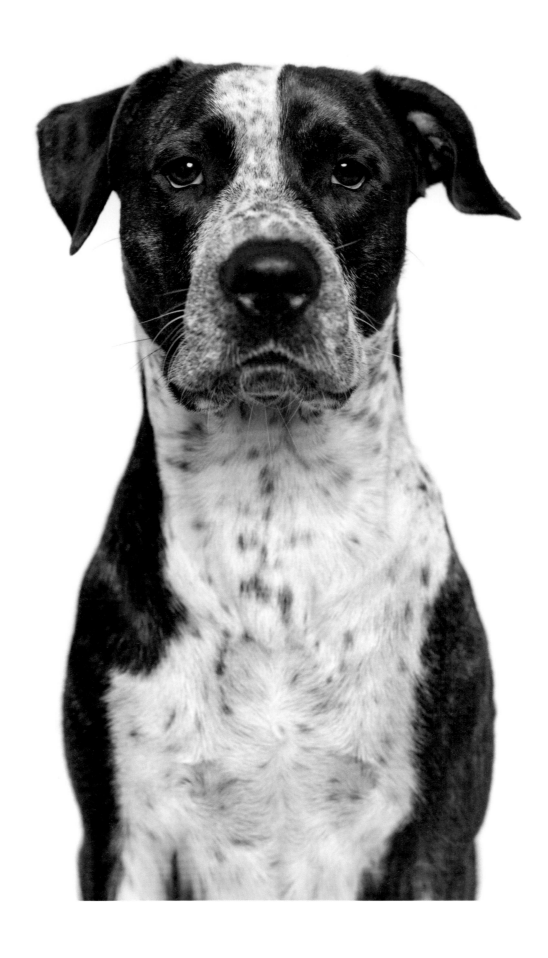

TITUS
Tibetian Terrier Mix

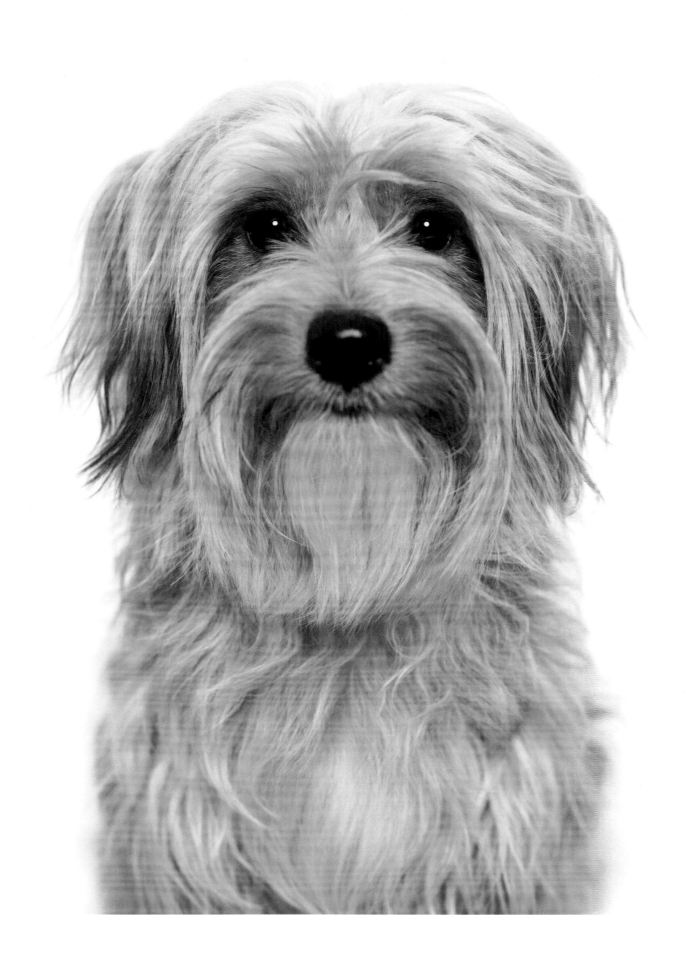

LILLY
Deutsche Braille

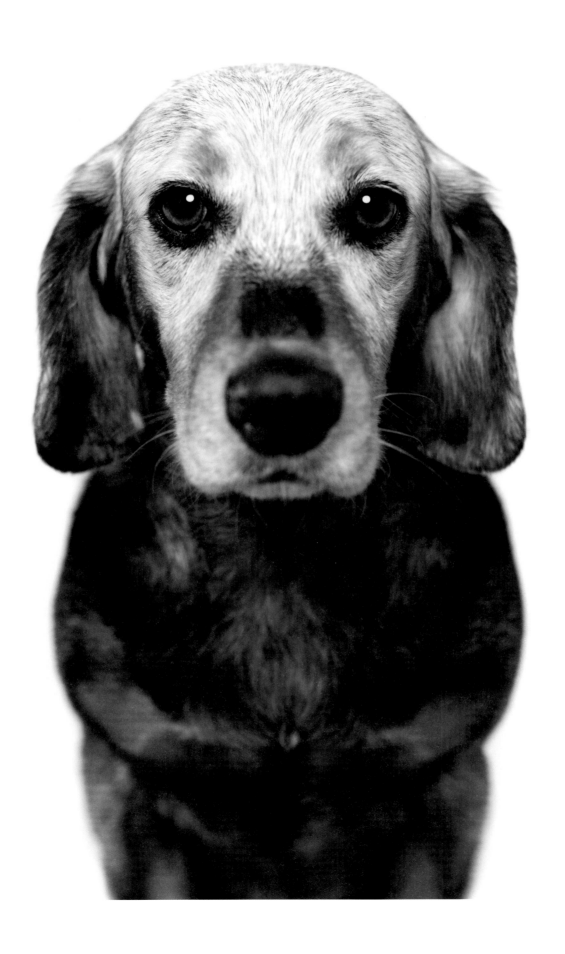

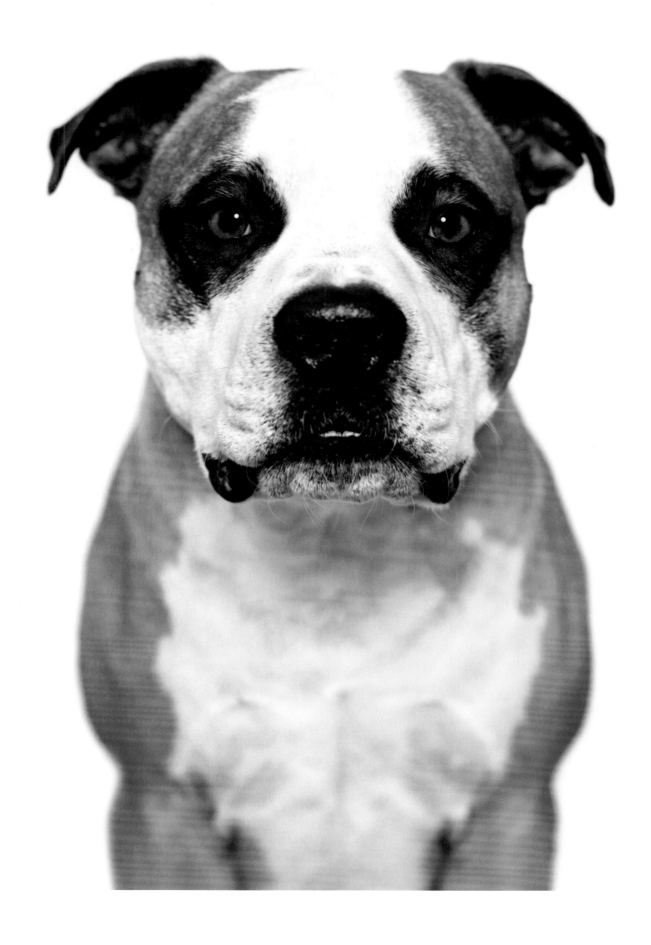

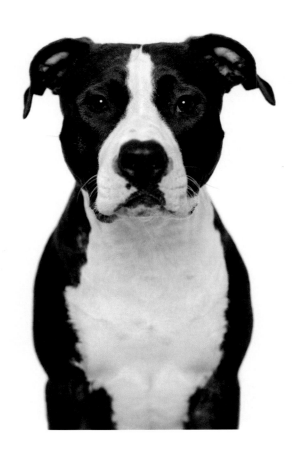

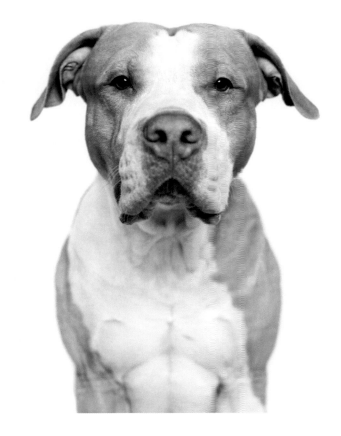

JAYDA
Staffordshire Terrier

PABLO
American Staffordshire Terrier

SHEYTAN
American Staffordshire Terrier

DR. BOLLE
Münsterländer Mix

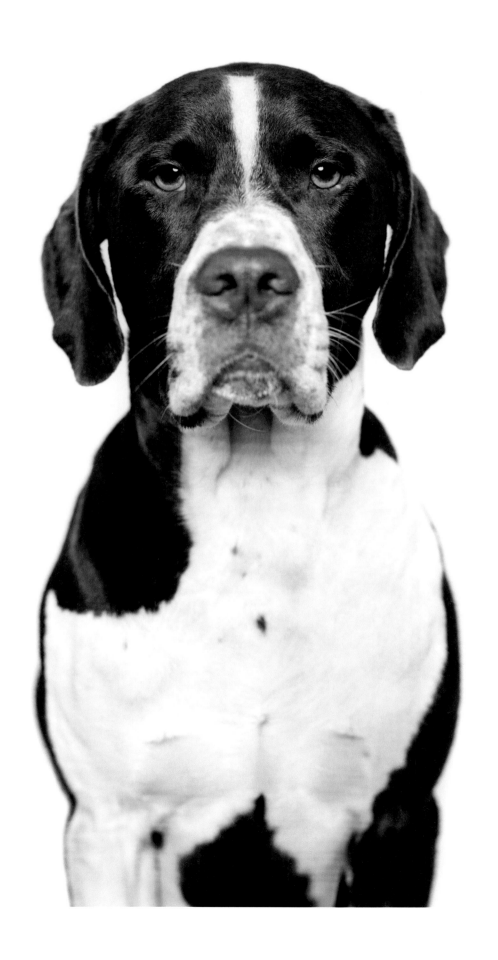

EDDIE
Lagotto Romagnolo

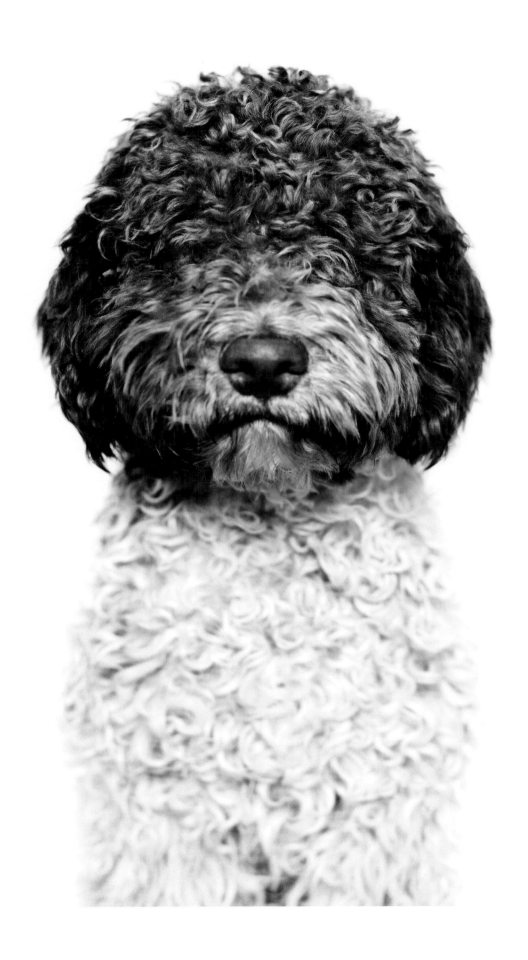

OTTO
Luzerner Lauf...

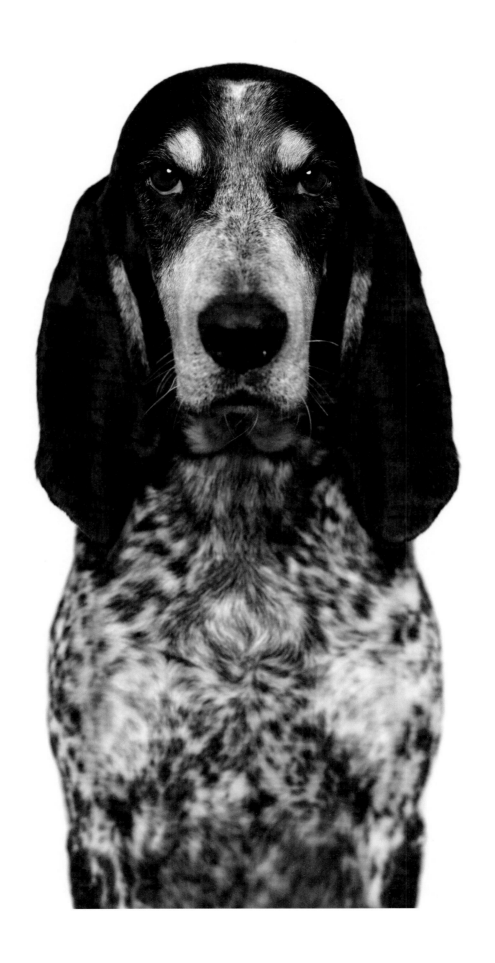

GANDHI
Staffordshire Bull Terrier

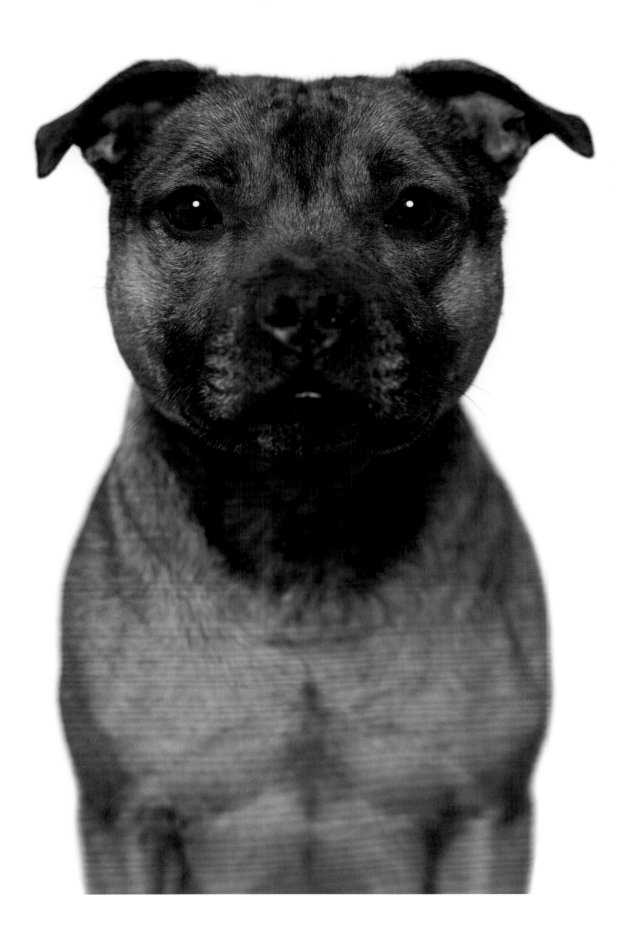

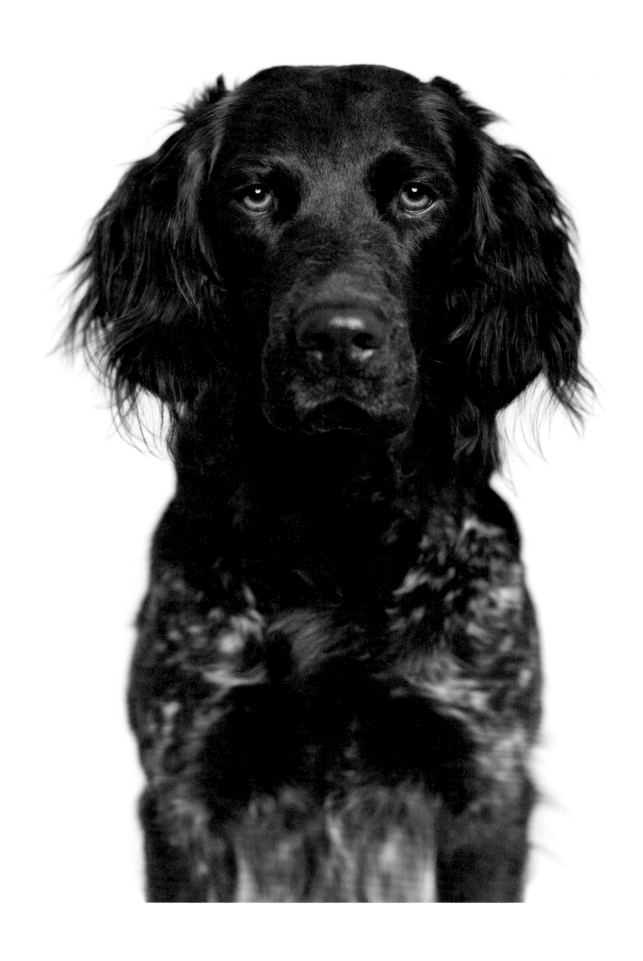

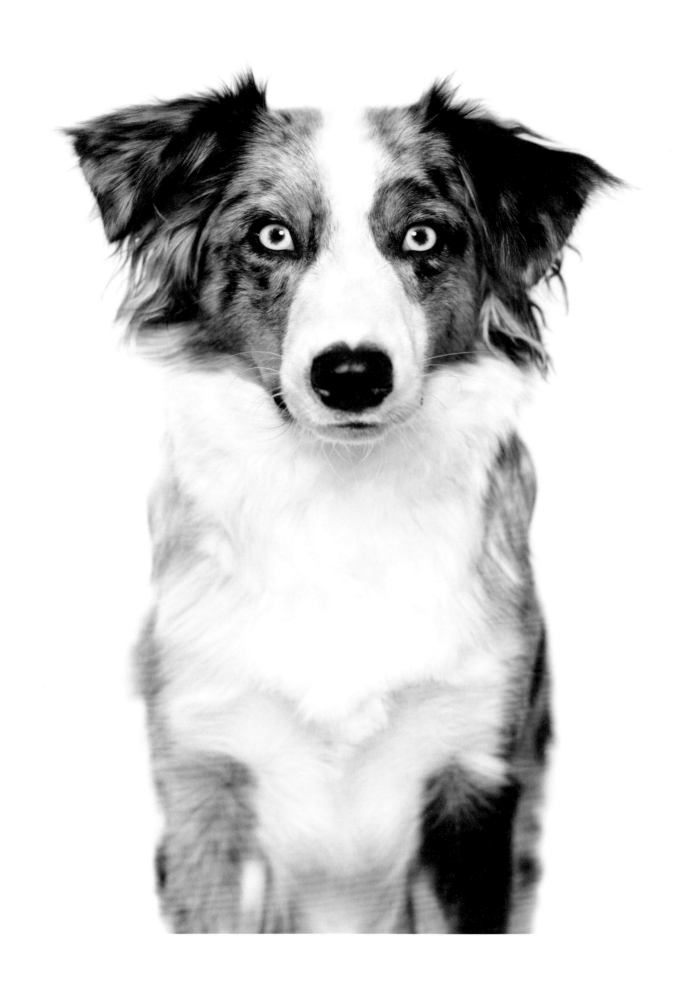

ERNA
Kleiner Münsterländer

HANNELI
Miniature Australian Shepherd

TIMMY
Zwergspitz

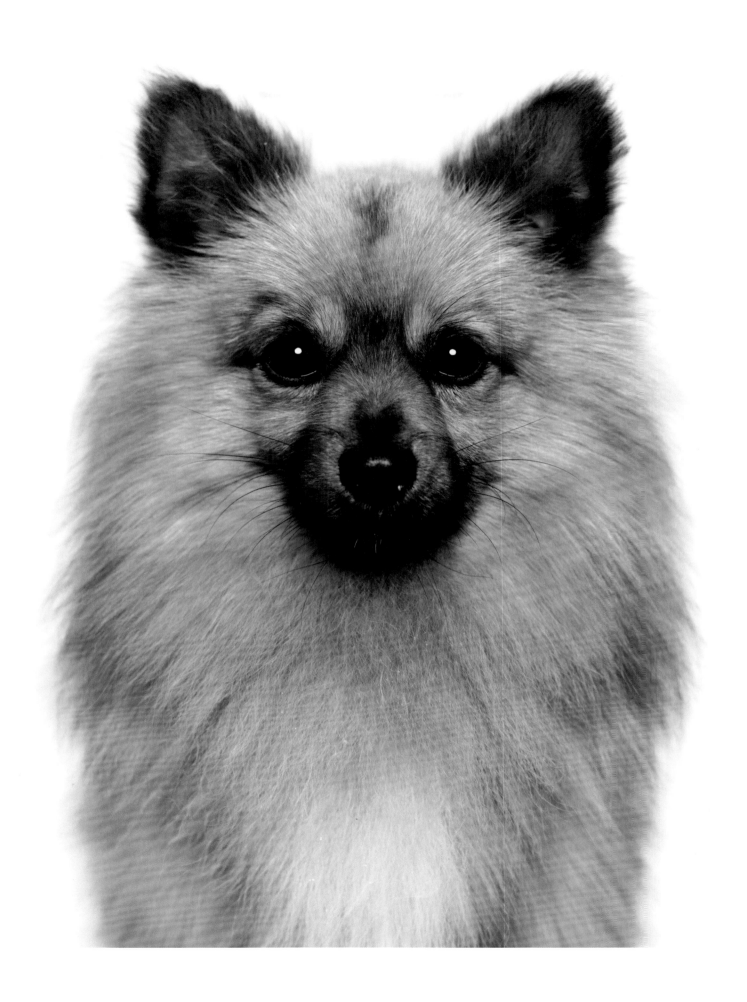

STELLA
Weimaraner

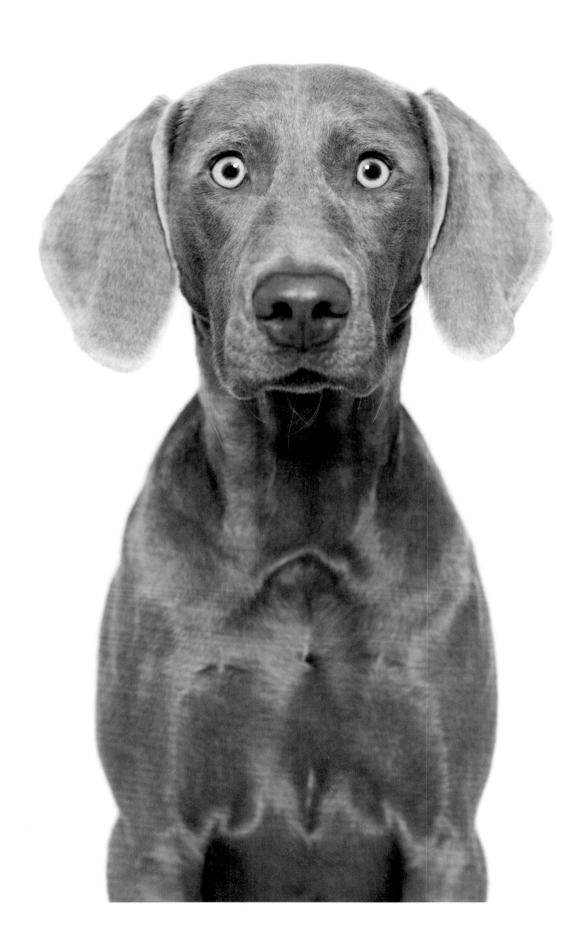

LILLY
Australian Cattle Dog

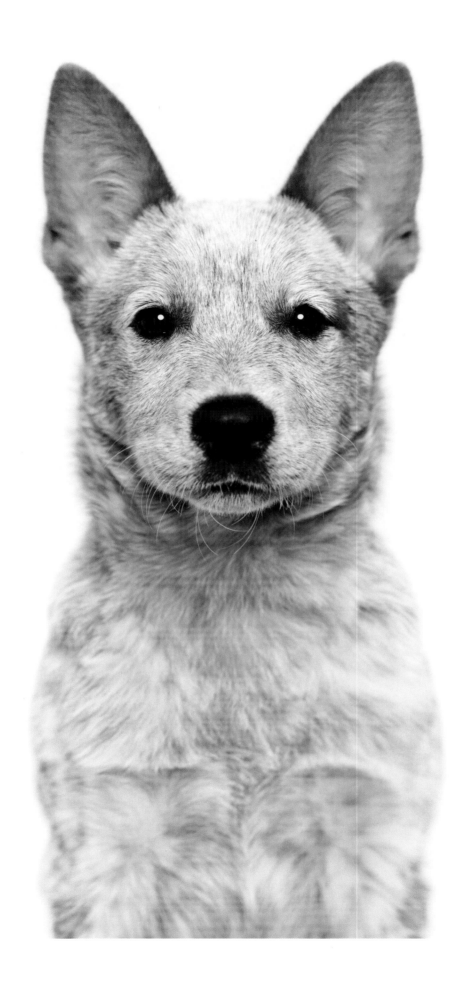

MOLLY MALONE
English Bulldog

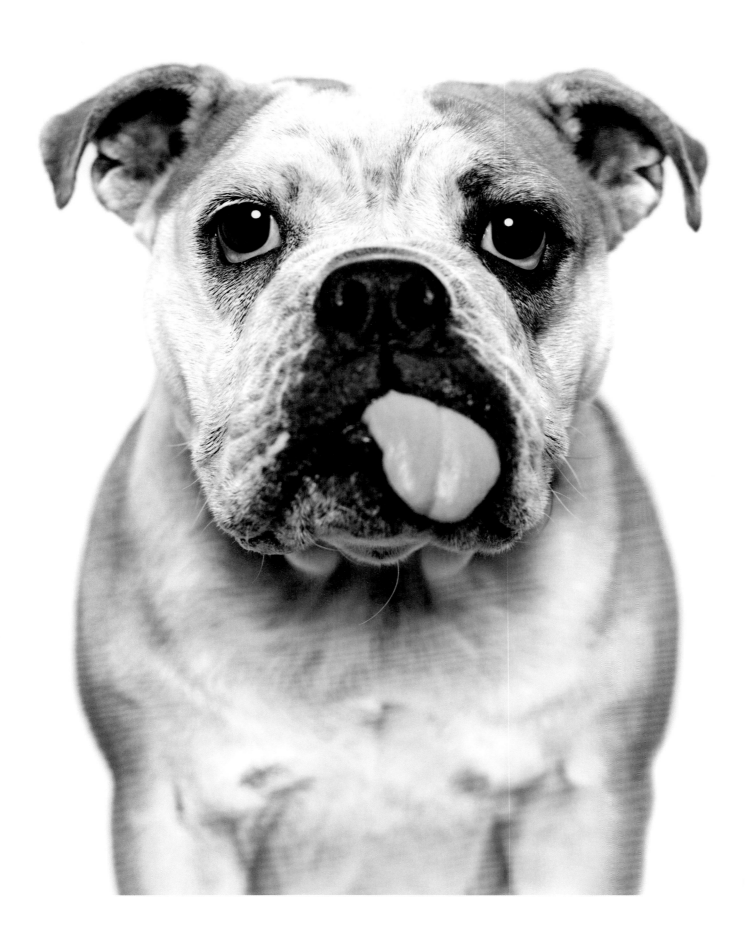

Imprint

SIT
First Edition 2017

Published by seltmann+söhne
Prinzenstr. 85 D, 10969 Berlin

© **for all images Matt Karwen**

Printed in Germany
Seltmann Printart, Lüdenscheid

The German National Library lists this publica-
tion in its database. Detailed bibliographic data
are available online at www.dnb.de

© **2017 seltmann+söhne**

ISBN 978-3-946688-19-8